IMAGES
of America

HADLEY AND
LAKE LUZERNE

D1496413

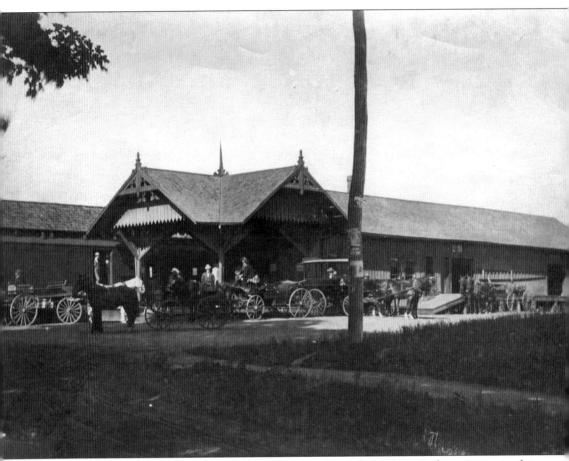

The Hadley station of the Adirondack Railway is pictured in 1900. Rail service arrived in Hadley in 1865 and became part of the Delaware and Hudson in 1902. The railway station was closed in August 1958, and the last freight train passed through on November 17, 1989.

IMAGES
of America

HADLEY AND LAKE LUZERNE

Hadley-Luzerne Historical Society

ARCADIA

First printed in 2002.

Published by Arcadia Publishing,
an imprint of Tempus Publishing, Inc.
2A Cumberland Street
Charleston, SC 29401

Printed in Great Britain.

Library of Congress Catalog Card Number: 2001098852

For all general information contact Arcadia Publishing at:
Telephone 843-853-2070
Fax 843-853-0044
E-Mail sales@arcadiapublishing.com

For customer service and orders:
Toll-Free 1-888-313-2665

Visit us on the internet at http://www.arcadiapublishing.com

CONTENTS

Acknowledgments 6

Introduction 7

1. Community Life 9

2. Local Industry 57

3. Vacationland 81

ACKNOWLEDGMENTS

We gratefully acknowledge the assistance of historian Beatrice Evens, Robert Green, Joan Hall, the Hadley-Luzerne Historical Society, Maureen Jones, Barbara Sebeck, and Rosemary Stanton. Special thanks go to Janet Letteron, who has made this task easier by her excellent records, pictorial and otherwise.

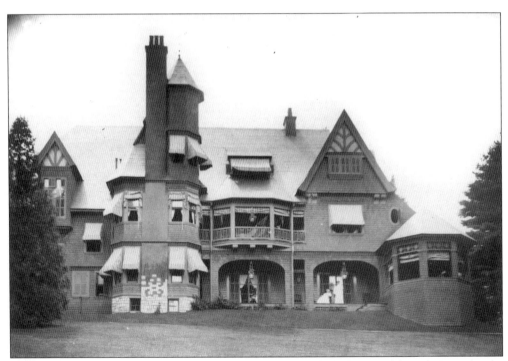

During the 1800s, life was lived on a grand scale. Hazelwood, the home of the Lily Price family, was located on the shores of Lake Luzerne.

INTRODUCTION

History is an ongoing process. Learning the history of the Hadley and Lake Luzerne area is to appreciate its natural beauty. Before these lands were settled, the Ice Age created its mountains, rivers, and lakes. One example is Rockwell Falls, a natural phenomenon that separates Hadley and Lake Luzerne. The Adirondack Mountains were, at that time, taller than the Alps. The rock deposits in these mountains are around a billion years old.

As the years passed, the land began to be developed by man. Native Americans passed through, but few of the tribes actually settled here. After the French and Indian War and the Revolutionary War, families began to inhabit the area. They came from neighboring states to settle here in the late 1700s. They cleared the land, built their homes, and cultivated the land.

Over the years, the communities of Hadley and Luzerne (as the town was known at that time) began to grow and families were established. As both towns began to organize in the early 1800s, it soon became apparent that an orderly way to conduct business was required. In the early days, many of the town meetings were held at private homes since there was no centrally located building available. Local justices dealt with only minor infractions, and the town fathers dealt with the everyday business of the towns.

People such as the Jessup brothers, who came from Connecticut, settled in the Hadley area. They were deeded large tracts of land that they used for logging. The logs were floated down the Hudson River to Glens Falls. It was the Jessups who named the area Fairfield.

Logging became a major industry. Not only were the logs a source of income, but they were also used for building homes in the area. The local terrain also provided good hunting for food and good soil for growing crops. As the families grew, the need for education arose. This need for education prompted the building of the one-room schoolhouses. Several of these still stand, and one is used as a museum in Lake Luzerne.

Industry began flourishing in the late 1800s. The huge amount of timber and the rivers (for transportation and waterpower) played a large part in this growth. The Union Bag and Paper Company, at the confluence of the Sacandaga and Hudson Rivers, thrived. The Garnar Leather Works, in Luzerne, was another large employer. Another local industry was a woodenware works factory, which produced toothpicks, clothespins, and other items. Ketchum Manufacturing—the oldest business in Lake Luzerne that is still operating—produced animal tags. Originally located on Wall Street in Lake Luzerne, the factory is now located on Town Shed Road and still manufactures animal tags.

With industry booming and employment high, a new industry appeared. Tourism became

one of the major employers of the day. It gave rise to many hotels: the Arlington Hotel and the Railroad House in Hadley and the Rockwell Hotel, the Elms Hotel, and the imposing Wayside Inn in Luzerne. They have all long since been destroyed by fire. The only buildings remaining are five cottages affiliated with the Wayside Inn. Four are private residences. One, the Queen Anne, is used as the administrative offices for the Hadley-Luzerne Central School. The school is located on the site of the original Wayside Inn. The Rockwell-Harmon Cottage, which is the last building associated with the Rockwell Hotel, is now owned by the Hadley-Luzerne Historical Society. It was donated by Miriam Harmon and is operated as an art center by the society.

During the era of the huge hotels, guests would arrive at the Hadley railroad station and would be met and transported by various carriages from the hotels or boardinghouses. Some of the dignitaries who visited were Ulysses S. Grant, Eddie Cantor, Diamond Jim Brady, Lillian Russell, and even a Rockefeller or two.

By the 1920s, some businesses were closing. The paper mill in Hadley and the tannery in Lake Luzerne were the primary ones. Several smaller manufacturing operations were terminated at that time as the result of the expense and shortage of raw materials. Logging and farming, however, still prospered. The communities were growing. The one-room schoolhouse was becoming outdated and, in 1910, a new high school was built on Main Street. It stood on the present site of the Glens Falls National Bank. Before the building of this school, the high school was located in Hadley, across from the Wesleyan Methodist Church. The Main Street School burned in 1954. Fortunately, a new school was in the process of being built on Lake Avenue, on the site of the former Wayside Inn. This school housed kindergarten through 12th grade. By 1973, the enrollment had increased to the point that it was necessary to build the Stuart M. Townsend Middle School. This school is located north of the village on lands provided to the school district by Homer Scofield of Lake Luzerne.

All of this development required houses of worship. The Methodist church was built on the River Road in the 1850s and is now located on Main Street in Lake Luzerne. The Rockwell Falls Presbyterian Church, built on River Street (now Bridge Street), was destroyed by fire in 1926 and was rebuilt. In both the building and rebuilding, local stone was used. The Wesleyan Methodist Church was founded in 1844 in Hadley and was located on Stony Creek Road. The building was later sold, and a new church was built on Route 9N in Lake Luzerne. The Church of the Holy Infancy began as a mission church of the Immaculate Conception parish in Corinth. The original building was razed, and a new building was erected with the help of workers on the Conklingville Dam project. St. Mary's Episcopal Church was organized in 1865 and received a great deal of monetary assistance from Benjamin Clapp Butler. It is still located on Lake Avenue in Luzerne. The Lynwood Baptist Church, located on the South Shore Road in Hadley, still functions today.

As the towns grew, it became apparent that a more organized and centralized form of government was needed. Therefore, the town formed its own boards, and the board of education was established.

It is very apparent that there have been many changes since the 1700s. Generations of families that spent summers here long ago have now become permanent residents, and the founding families still carry on as well. Many residents can trace their ancestry to the early settlers. We hope this book will give you an idea of the early beginnings of Hadley and Lake Luzerne. Through industry, community life, and tourism, the region has come a long way. Parents and children should study the pictorial history. Perhaps they will see their ancestors there.

—Barbara J. Sebeck
President, Hadley-Luzerne Historical Society

One
COMMUNITY LIFE

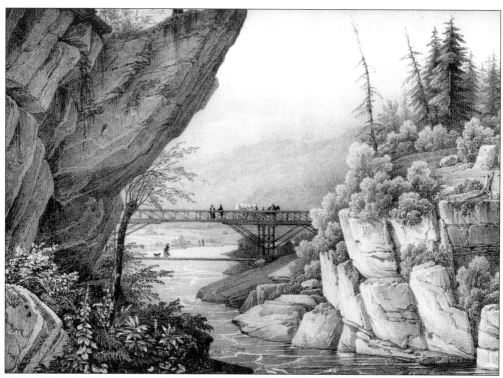

The earliest known man-made connection between Luzerne and Hadley was the footbridge shown in this print. Above the footbridge is the subsequent covered bridge, which allowed carriages and other conveyances to cross between the towns. The footbridge remained until it became impassable.

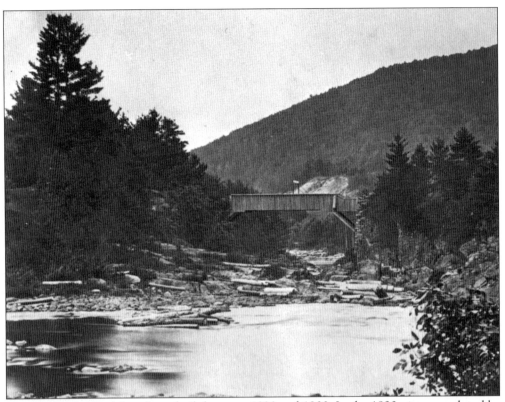

The wooden bridge (above) was built between 1890 and 1900. In the 1920s, it was replaced by an iron bridge (below), which was replaced by the existing concrete bridge in 1932.

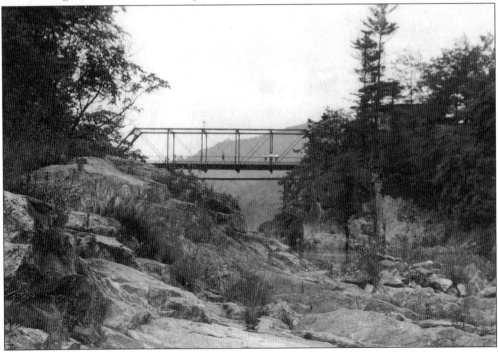

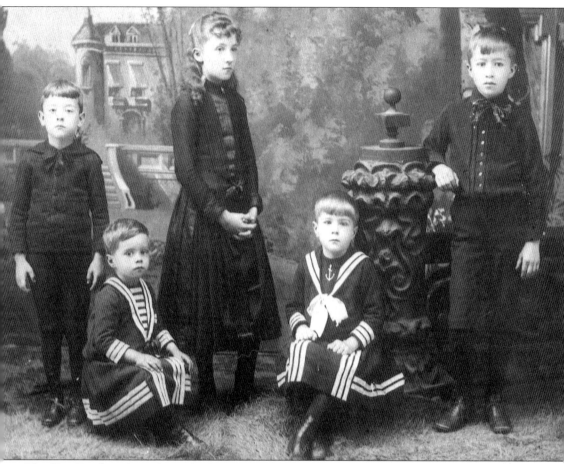

The Van Zandt and Gardiner children (all members of prominent Hadley families) are shown in a special studio portrait, judging by the backdrop. They are, from left to right, Robert Van Zandt, Charles Gardiner, Elizabeth Hoyt Van Zandt, Harold Gardiner, and Rockwell Gardner.

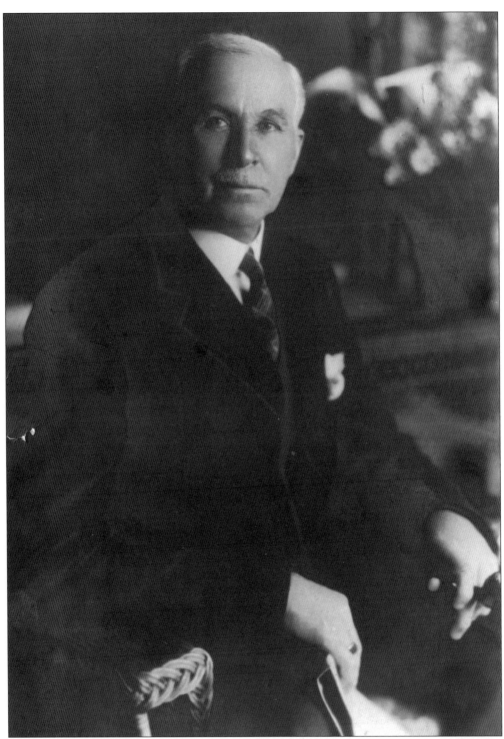

There were many businessmen and entrepreneurs in Luzerne during the 19th century. This formal portrait is of W.T. Garner, an important businessman of the time. He owned and operated the Garner Leather Works.

This proper lady in all of her finery is a member of the Garner family, probably the wife of W.T. Garner.

Three-year-old Sydney R. Garner, dressed in the attire of the day, is absorbed in his toys. He was probably the son of W.T. Garner.

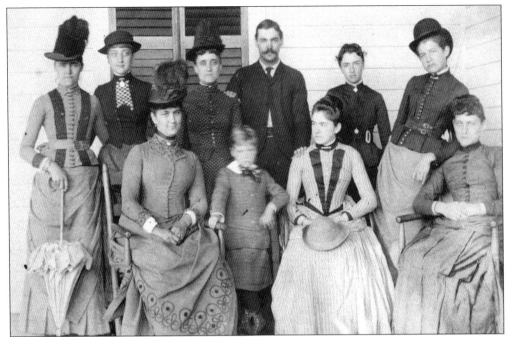

A group of ladies and gentlemen sits for a portrait in the early 1900s. Third from the left in the front is Elizabeth Rockwell Winsor. The man with his hand on her shoulder is probably her husband, Harry Winsor.

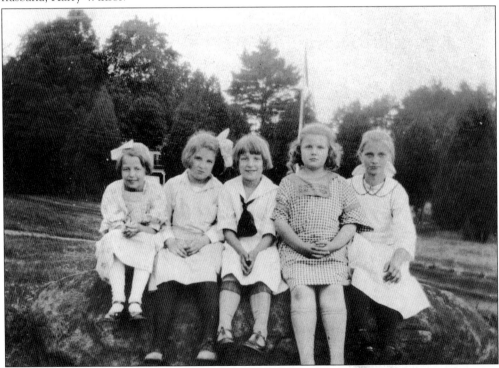

The members of this early-1900s Sunday school class are, from left to right, Hazel Thompson Garner, Thelma Rice, Helen Wright, Virginia Smead, and Leona Tubbs.

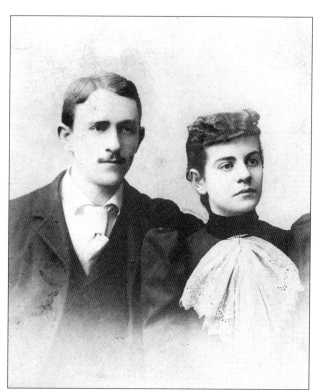

Dr. George R. and Blanche Coupe Thompson are shown in a formal portrait. Their sons are pictured below on the front steps of their home on Church Street in 1903.

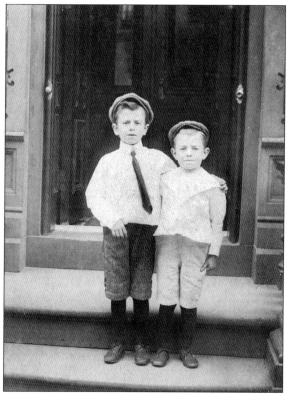

William J. and Annie Garnar
Kinnear were the parents of
Frances Kinnear, benefactor of
the Hadley-Luzerne Historical
Society. They were part of the
intermingling of the Garner and
Kinnear families.

Harvey R. Palmer is ready to serve his country in World War I.

This beautiful child is Jean Wilkinson Horton. She was to be adopted by Anna Fowler Horton, but the adoption was never completed. Jean disappeared mysteriously, and it was thought that her father had taken her. However, nothing was ever proven.

17

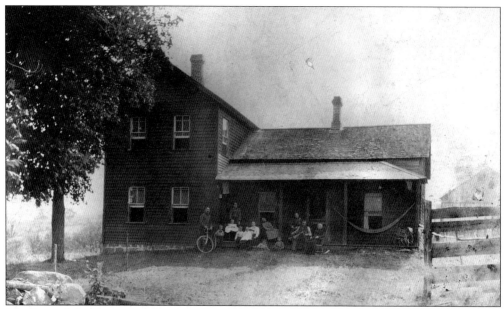

Members of the Gailey family enjoy their front porch. This is the J.J. Gailey Farm, located on Hadley Hill in Hadley, in the mid-1800s.

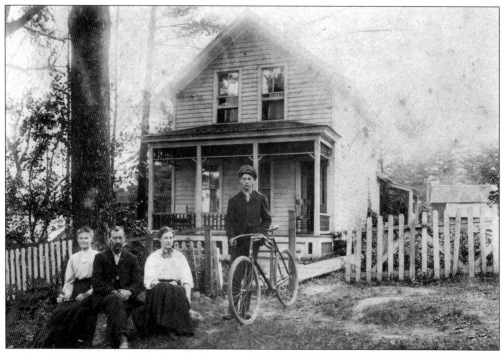

Jacob and Eliza Rist—with their daughter Mabel Rist (Bennett) and their son Frank Rist—pose in front of their home on Hill Street. The daughter became the mother of many of the Bennetts who still live in the area.

Tiglath Pileser, beloved dog of Frances Kinnear, is pictured *c.* 1915. He seems to be waiting for a treat.

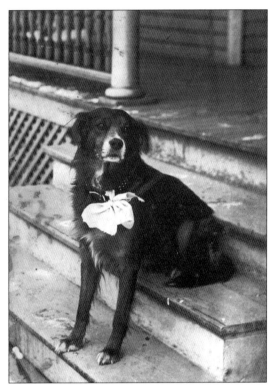

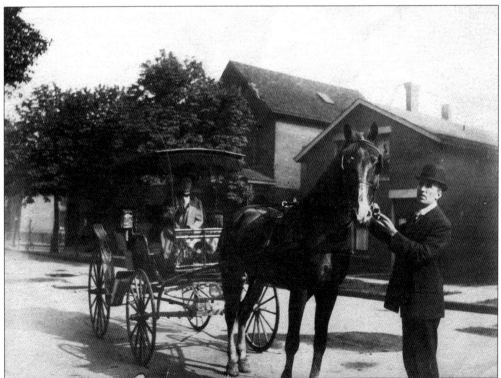

Pete Lowe, coachman for John Payne (in the carriage), checks the harness before driving off.

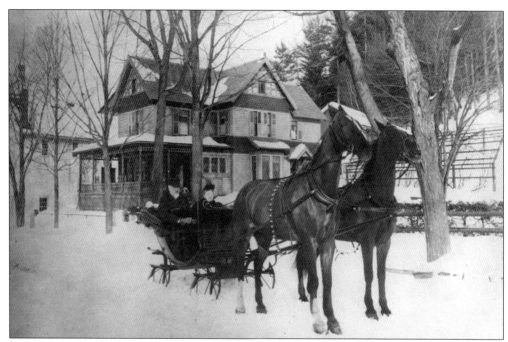

Thomas Garnar and his sister are out for a sleigh ride in a cutter drawn by a pair of mixed bays that are adorned with sleigh bells. The house behind them is the Garner home, which later became the Kinnear home.

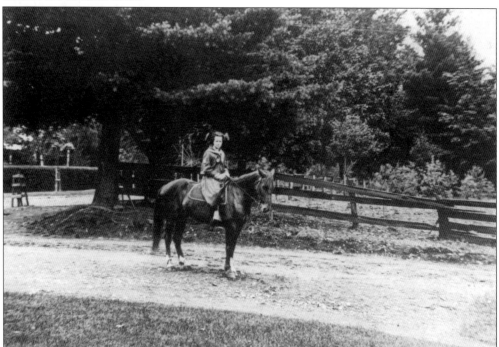

Frances G. Kinnear exercises her horse c. 1915. She was an outdoor girl who liked skating and snowshoeing. Later in life, she founded and operated a girls' summer camp on Second Lake in Luzerne.

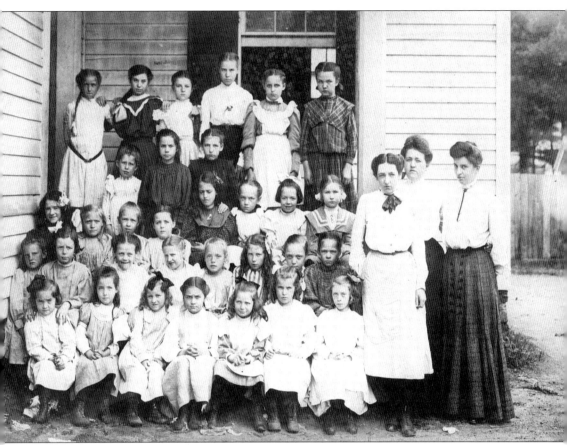

Students pose in front of School No. 1 (on School Street) in the late 1800s or early 1900s. They seem to be unhappy with their plight but are probably just camera-shy.

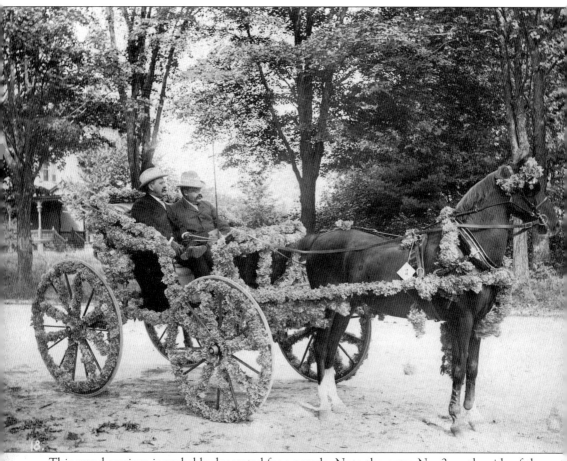

This grand carriage is probably decorated for a parade. Note the entry No. 2 on the side of the horse. This one should be a winner.

Joseph Linindoll is celebrating his third birthday on the lawn of the Elms, a hotel located on the site of the current tennis courts on Main Street. This Elms is not to be confused with the McMaster house on Bay Road.

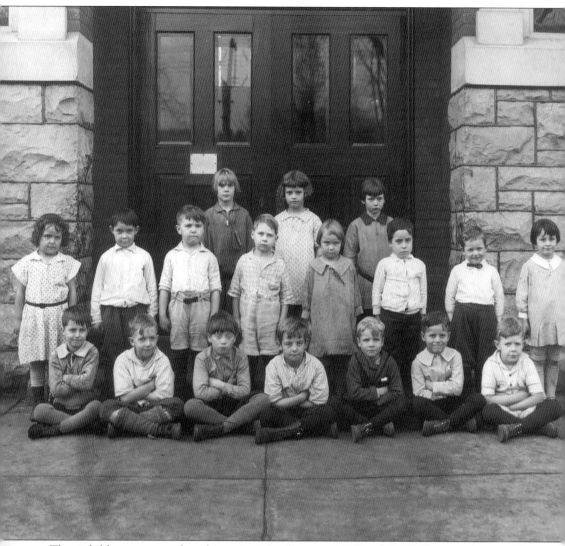

These children are part of an elementary class between 1925 and 1930. They are shown in front of the Main School, which was, at that time, located diagonally across from the former post office on Main Street.

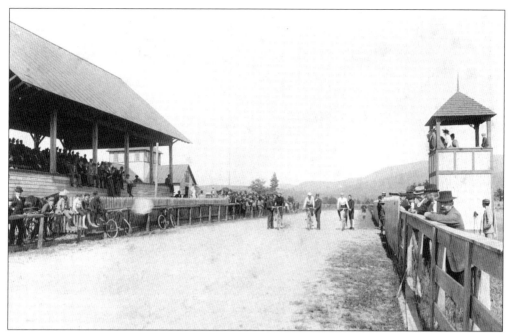

The fans in the grandstand are enjoying a bike race at the Luzerne Fairgrounds c. 1920. The fairgrounds were located in the area of the present bowling alley on Route 9N.

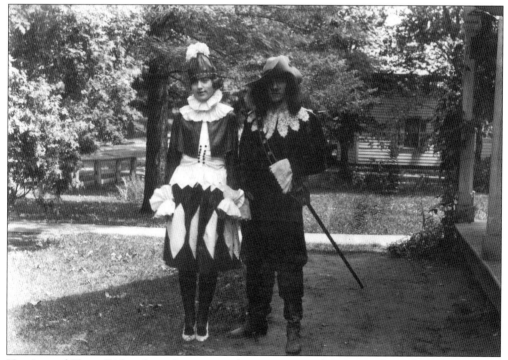

Harriet and Knox Bishop have been invited to a masquerade party and are dressed as Romeo and Juliet c. the 1920s.

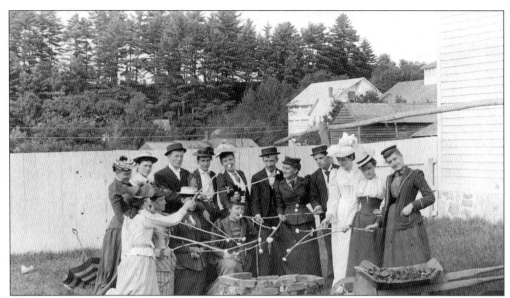

There were always standard community activities during the summer. This group is enjoying a marshmallow roast in 1891.

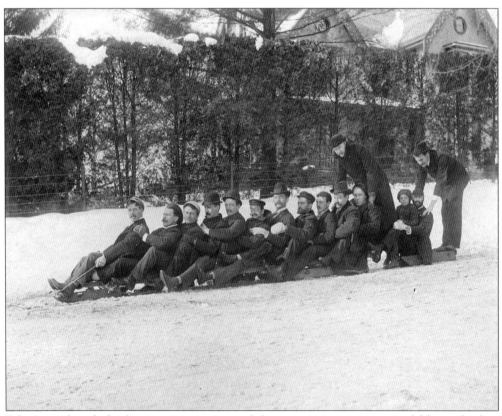

Fifteen unidentified tobogganers enjoy one of the many winter sports available in the late 19th century.

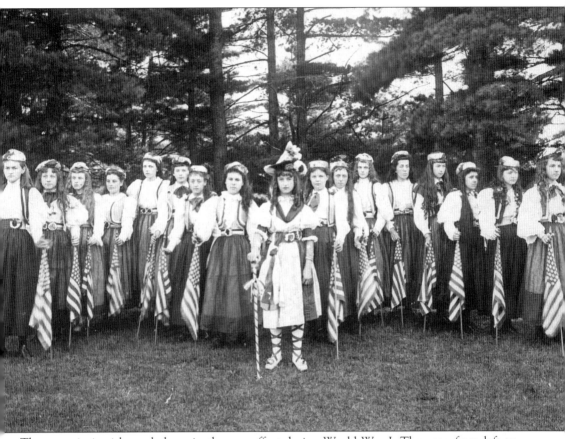

These patriotic girls are helpers in the war effort during World War I. They are, from left to right, Estella McCarthy, Lottie Scoville, Bertha Champagne, Ida Shay, Emma Howe, Harriet Hovey, Mamie Grutzner, Marie Oheisman, Ella Underwood, Emma Wigley, Freda Grutzner, Cordelia Allen, Anna Snell, Florence Willy, Bessie Hovey, Helliot Buck, and Lena Scoville.

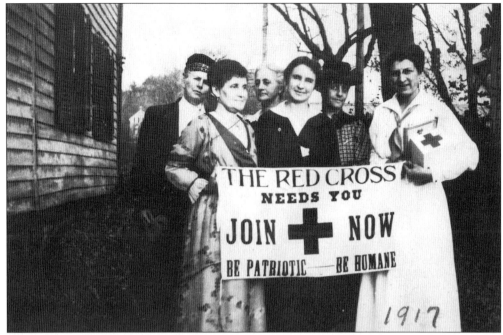

Patriotic Americans in Luzerne and Hadley are helping the Red Cross with relief work in 1917.

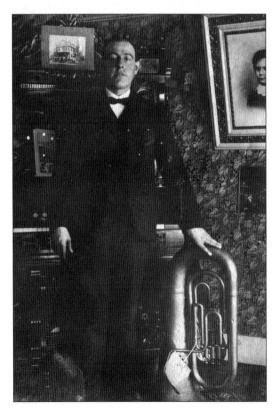

J.F. Goodness is showing his musical side. It is believed he did play the French horn but not the piano.

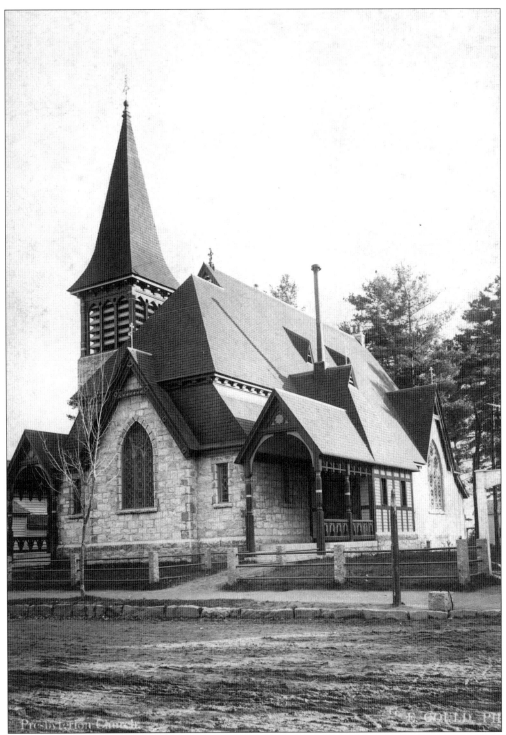

This is the stately original Rockwell Falls Presbyterian Church, located on Bridge Street in Luzerne. The church burned in the 1920s and was replaced with the current edifice. Both churches incorporated local stone in the building.

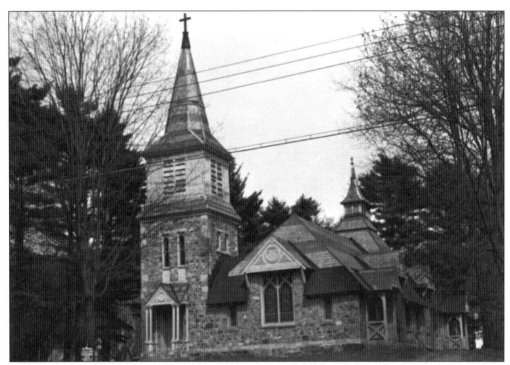

St. Mary's Episcopal Church services were first held in 1875. Col. Benjamin Clapp Butler was a major contributor to the building of the church. Bishop William Croswell Doane laid the cornerstone for the church in 1874.

Rev. Wilbur Wager (an Evangelist) and Samuel Inman (Leader of Song) are preparing for a camp meeting, probably at the fairgrounds on Route 9N.

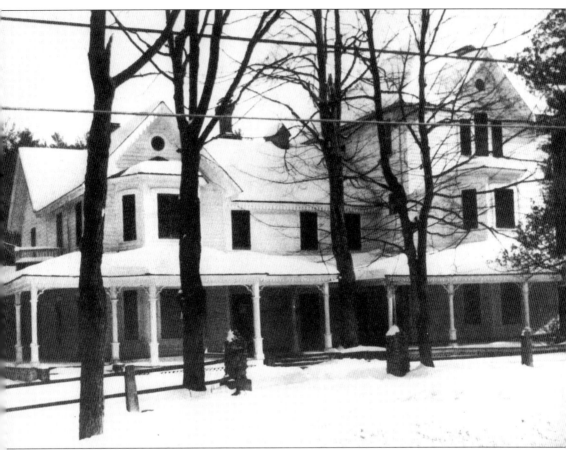

Nicholas D. Clapp built the Clapp house in the late 19th century. It is recorded that the building cost $25,000 to build. There was no expense spared. The site included a boathouse, stable, garage, and servants quarters. It was later owned by Philip Schemerhorn of New York City. Joseph Brunetti purchased the building in the late 1940s. He had the building razed in the 1950s. The land is now owned by the Town of Lake Luzerne and is used as a park area.

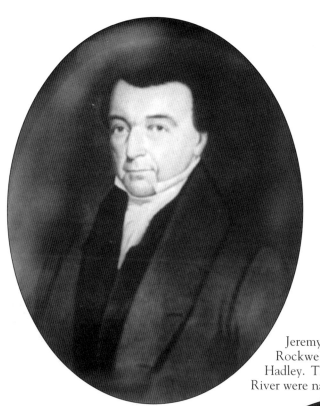

Jeremy Rockwell and his wife, Betsy Bird Rockwell, are two of the founders of Hadley. The Rockwell Falls in the Hudson River were named after that family.

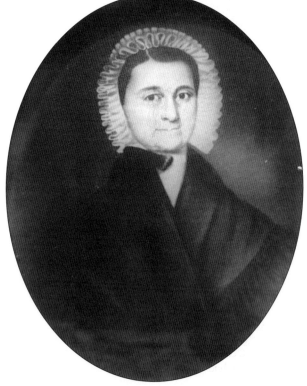

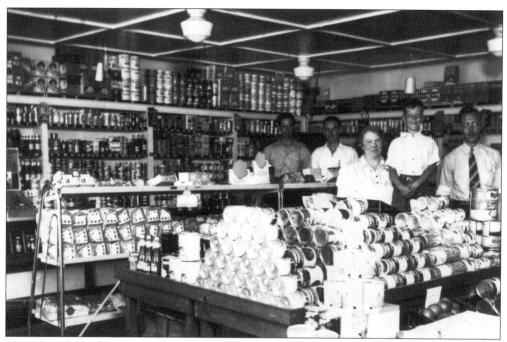

There has always been a grocery store on the Four Corners in Hadley. Clyde Rollman Sr., one of the earliest owners of the store, is pictured on the right with wife Ethel and Clyde Rollman Jr. Two workers are standing in the back.

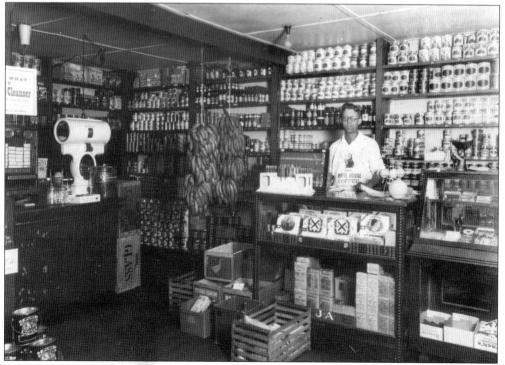

Luzerne also had a corner store, located at Church and Main Streets. The storekeeper is Win Stone.

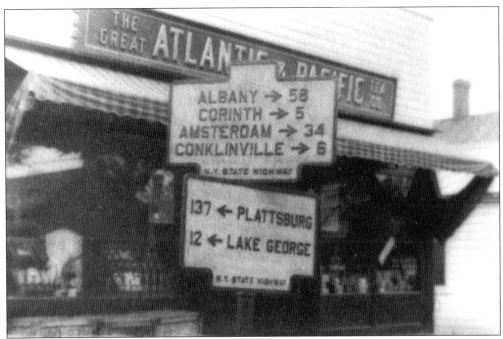

From the corner of Main and School Streets, you could get almost anywhere in the area, as indicated by this sign in front of the Great Atlantic & Pacific Tea Company in Luzerne in the 1930s.

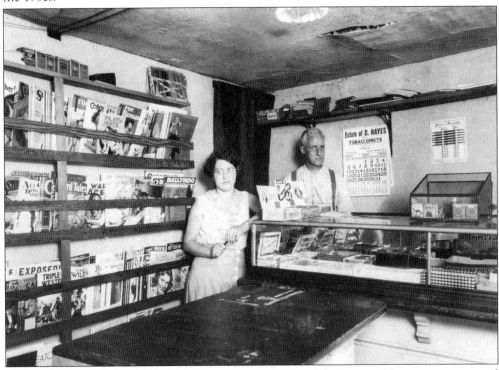

Every town has a news store, and Luzerne was no exception. The Luzerne Newsroom was owned and operated by William LaMoy. He is shown here with his daughter Eva.

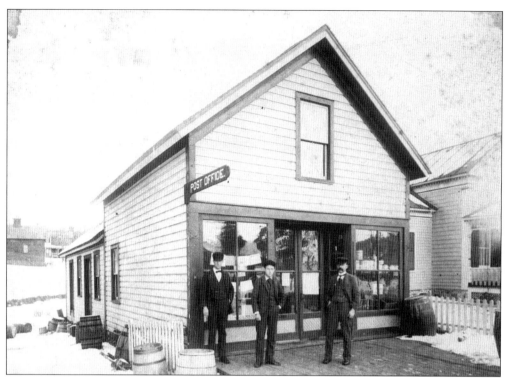

Dr. James Porteous and Dr. John Burneson stop to chat with a man in front of the Luzerne post office when it was located on Main Street. Then, as now, the post office was the hub of the town.

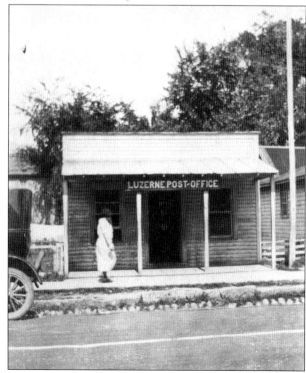

The original Luzerne post office is open for business in this photograph. The building was located on River Street (now Bridge Street), across from Morton's Meat Market.

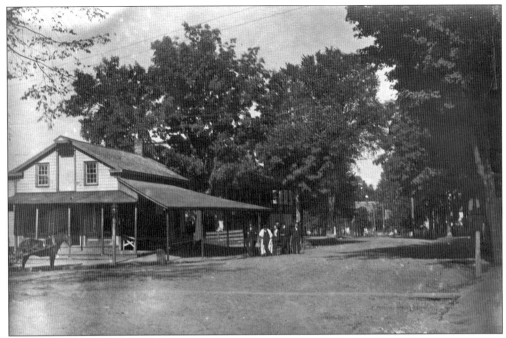

Morton's Meat Market was an important part of the community, as it provided meat and groceries to the towns. In 1871, the building was a jewelry store run by E. Dayton. Stephen V. Morton opened the grocery and meat market in 1878.

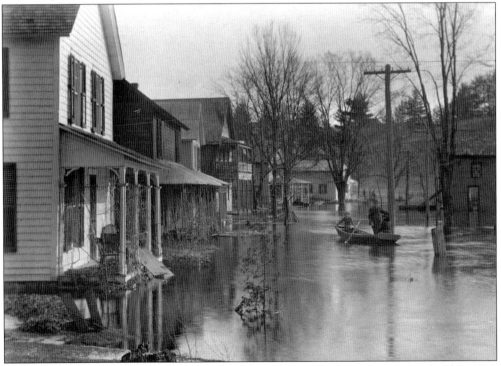

In the early days, there were always natural hazards that had not been tamed. This 1913 photograph shows an inundated Wall Street in Luzerne.

The Kinnear house, on the corner of Center Street and Lake Avenue, is where Frances Kinnear (benefactor of the Kinnear Museum of Local History) was born.

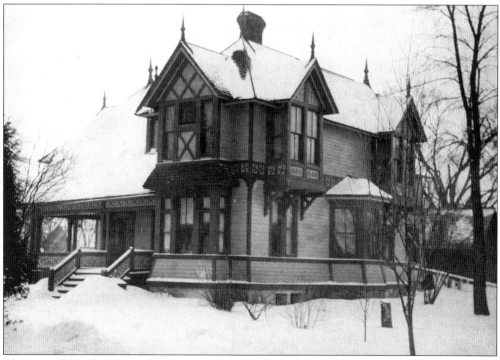

The beautiful and unique McMaster house is now known as the Elms, located on the corner of Bay Road and Route 9N. It was originally a Catholic girl's camp.

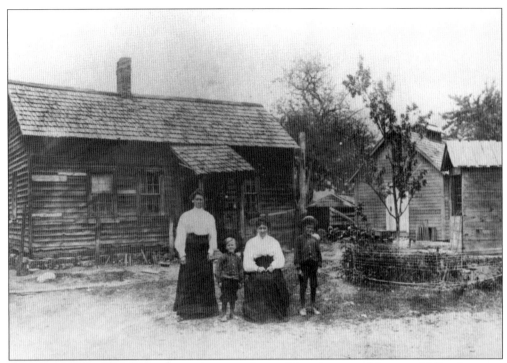

Members of the Hartman family are shown in front of their home on Hartman Hill in Luzerne. They also had a sawmill on this site.

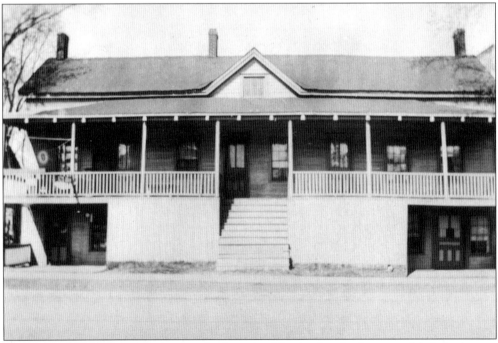

This unusual building was built around a huge boulder (under the front porch). It had many boarders and was therefore called the Beehive. It was located on Main Street next to the Morton House across from the present market.

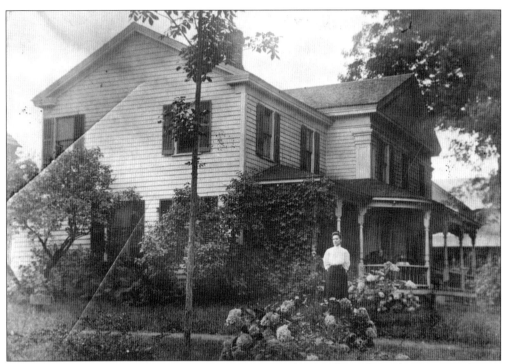

Frances Burmeson, the wife of John Burmeson, surveys her lovely garden. The Burmeson home, formerly the Porteous home, is still located on Main Street (next to the current market).

This stately home on Church Street was originally the W.T. Garnar house. It is now the Brewer Funeral Home and is still located on the corner of Church Street and Lake Avenue.

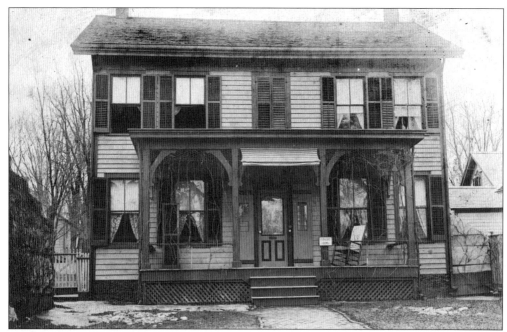

The Pulver family originally owned this house. It still stands but was altered in appearance after the Mortons purchased it.

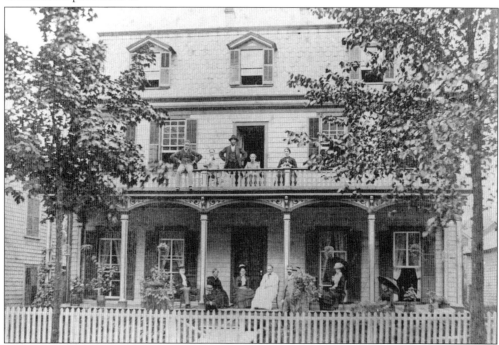

The Morton House was a family home and was also run as a boardinghouse for vacationers in the late 1800s. Located on Main Street next to the Beehive, it was originally the Pulver House. When it was purchased by the Mortons, a third story and a mansard roof were added. The building still stands today and, although much else has changed, the mansard roof is still the distinguishing feature.

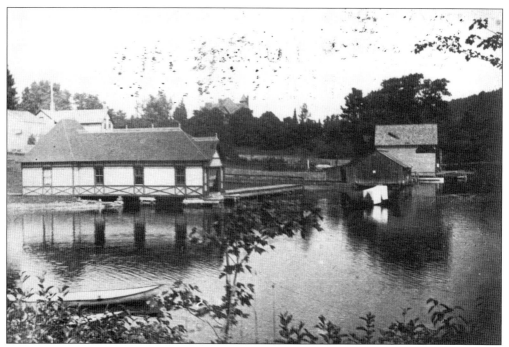

Howard Conkling's boathouse on Lake Luzerne was Victorian in style. As well as the necessary boat slips, there was a fine clubroom in the rear with a large carved wooden eagle hung on the rear wall. Boats were rented from Wigley's boat livery in the background.

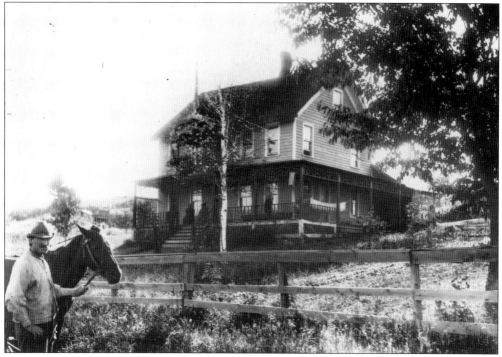

In the late 1800s and early 1900s, there were many boardinghouses in the area. This boardinghouse, Grandview, was located on River Road and was owned by the Ives family.

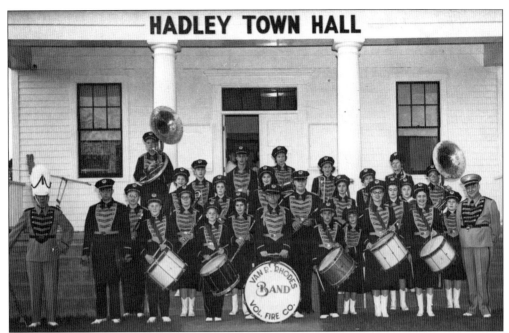

In the 1950s, weekly band concerts were a big part of community life. This band was formed by the Van R. Rhodes Volunteer Fire Company. Anyone with any talent in that area participated—young, old, and in-between. The concerts were held at the bandstand on the Four Corners in Hadley.

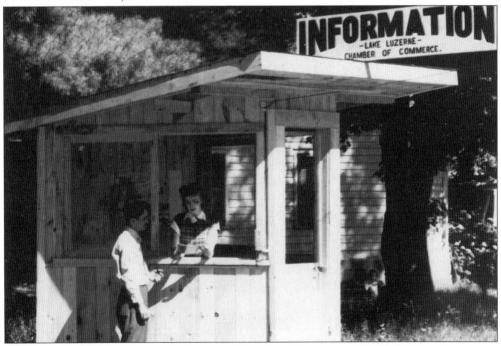

The 1950s brought to life the Lake Luzerne Chamber of Commerce. Its first information center was located on East River Drive and Route 9N. In this view, Myra Brannon is helping Raymond Waterhouse with directions.

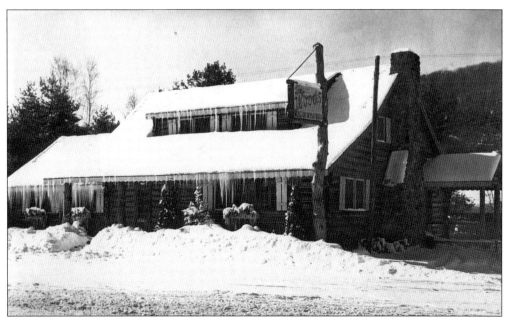

In the 1940s and 1950s, the Woods Restaurant was the place to be. It was famous for its annual clambakes in the pavilion behind the main restaurant. The building was demolished in 2001.

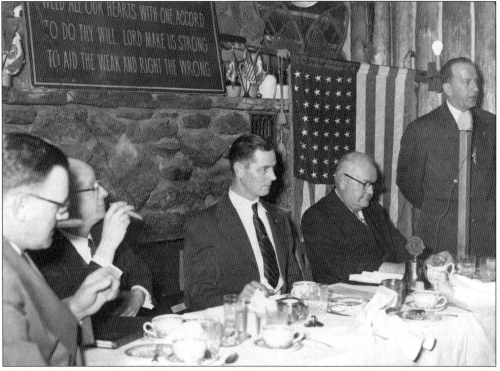

The Hadley-Luzerne Lions Club members held their meetings at the Woods Restaurant. In this photograph, they have enjoyed good food and some are enjoying a good cigar. They are, from left to right, Hubert Frasier, Rev. H. Borden Adams, Clyde Wood, unidentified, and William Grant (one of the founders of the Hadley-Luzerne Lions Club).

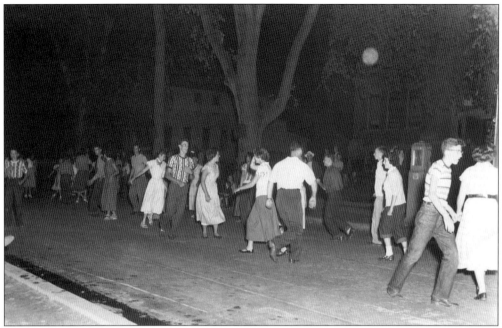

In the late 1950s, a street dance was where most teenagers congregated, and Luzerne was no exception.

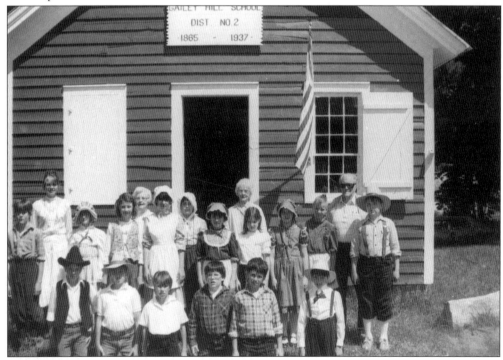

Fourth-grade students of the Hadley-Luzerne Central School reenact a school day at the Gailey Hill one-room schoolhouse. The schoolhouse was moved from the Hall farm on Gailey Hill Road to town property behind the present bank. This was done through the auspices of the Hadley-Luzerne Lions Club.

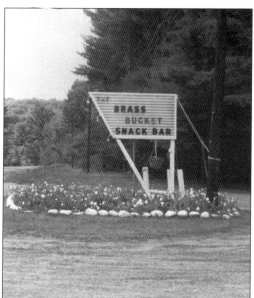

The Brass Bucket was a landmark in Lake Luzerne from 1960 to 1992. Al and Julie Adelmann began their enterprise as an open-air snack bar with several seats. As the business grew, the snack bar was enclosed and they remained open year-round. This was very handy for anyone out riding horseback. They even had a hitching rail. Their primary drawing card was the Brass Bucket Hot Dog (a hot dog with cheese wrapped in bacon with a secret sauce). Julie was also a fantastic baker and produced some of the best cream pies in the area. They closed their doors on June 14, 1992, and retired to their home next door. Many have tried, but no one has ever re-created that sauce.

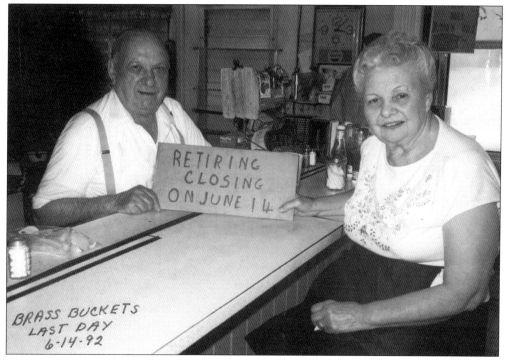

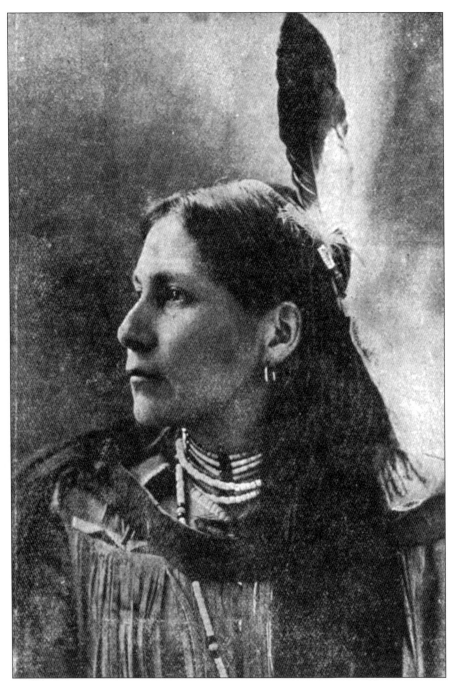

Anna Fuller (Falling Star) was an Abenaki Indian who resided for many years in Luzerne. She was the daughter of Lewey Dennis and Ellen Lawless Paul and was the granddaughter of the famous Adirondack guide Mitchell Sabattis. She was married to Silas Fuller, and they were basket makers by trade. An example of her work is on display in the Kinnear Museum. She also became a noted model and traveled to New York City on a number of occasions to model for artists and sculptors. She died on January 16, 1903, of injuries she suffered in a train accident and is buried in Luzerne Cemetery.

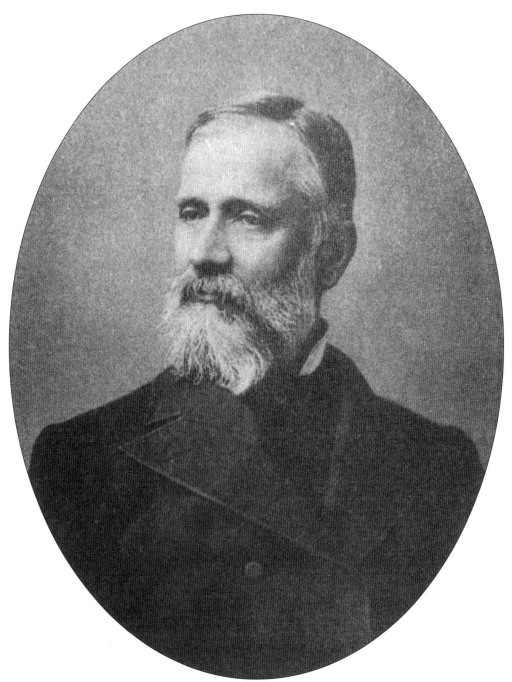

Col. Benjamin Clapp Butler (1820–1882), a military officer, businessman, and political leader, is one of Luzerne's most famous citizens. He served in the Civil War and fought at the Battle of Petersburg, Virginia. The local post of the Grand Army of the Republic was named for him. He served in a number of elected positions in Luzerne, including town supervisor (1875–1876). His greatest achievement was the Wayside Inn, which was built in 1869 along with surrounding cottages. He worked to bring tourism to Hadley and Luzerne and was the leading force in bringing the Adirondack Railway north through Hadley.

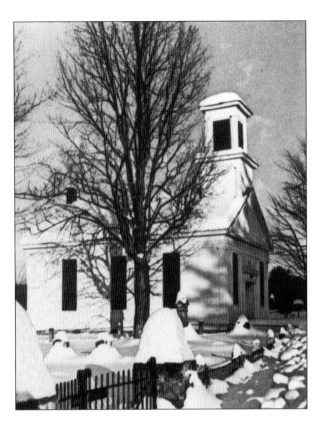

The Lynwood Baptist Church in Hadley is one of the area's oldest places of worship, and its adjoining cemetery contains some of the earliest grave markers in Hadley.

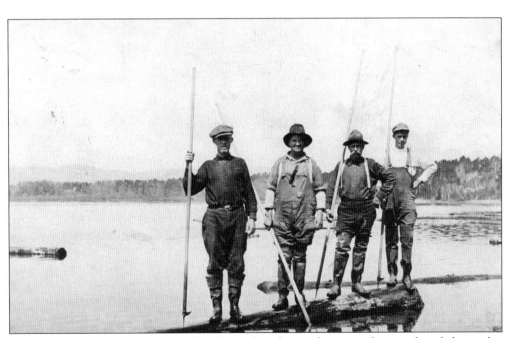

Pictured is a log drive on the Sacandaga River. Standing with great agility are, from left to right, Howard Baker, Floyd Baker, ? Palmer, and George Palmer.

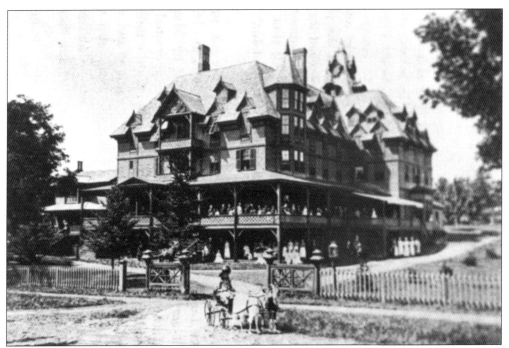

Note the goat cart in this interesting photograph of the Wayside Inn.

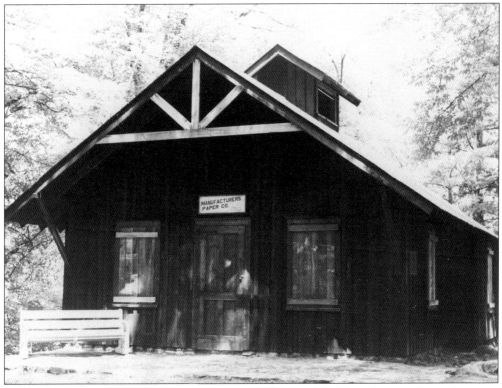

The Old Mill Museum in Lake Luzerne contains exhibits of the Manufacturers Paper Company and early papermaking.

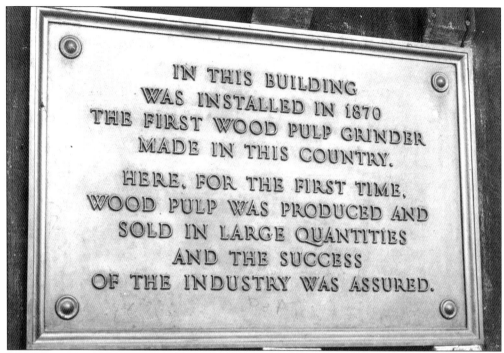

This bronze plaque from the Manufacturers Paper Company is exhibited at the Old Mill Museum.

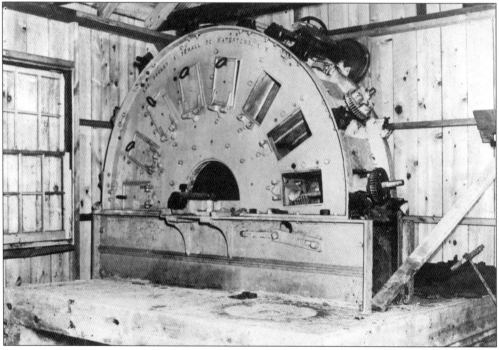

The first American-made pulpwood grinder is on display at the museum. Pulpwood was forced against a water-powered and water-cooled grindstone to produce fine wood fiber that was used in papermaking.

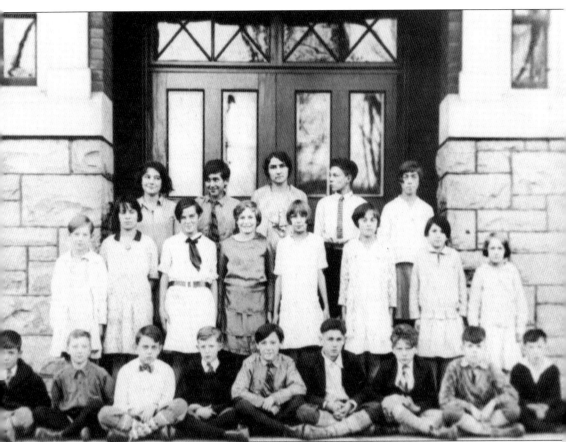

Taken at the old high school on Main Street, this photograph shows, from left to right, the following: (front row) Don Fowler, Alfred Pike, Don Perkins, Walt Crannell, Cecil Hayes, unidentified, Don Stanton, Paul King, and Frank Tom Beattie; (middle row) Ruth Hagadorn, Esther Brown, Dorothy Wood, Edith Mosher, Gladys Gillies, Dorothy Dean, Elizabeth Pike, and Marion Hall; (back row) Irene Hayes, unidentified, Blanche Parker, Ray Wood, and Mildred Scoville.

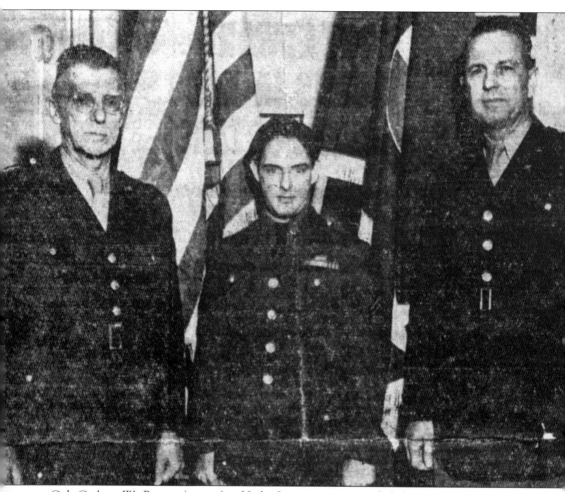

Cpl. Carlton W. Barrett (center), of Lake Luzerne, was awarded the Medal of Honor for his valor on the Normandy beachhead on June 6, 1944. Nicknamed "Mighty Mite," he was 5 feet 3 inches tall and tipped the scales at 130 pounds. During the invasion, his landing vehicle struck a sandbar some 200 yards from shore. Under heavy enemy gunfire, many of the soldiers were forced overboard. Barrett treated the wounded and helped carry them to an evacuation boat. Assuming the responsibilities of a lieutenant who had been wounded and treated by him, Barrett guided his regiment's boats to safe landing places. He was stopped only by wounds in both hips and legs. He later commented, "I did what I had been taught to do. The Infantry is a team and I was doing my job as a member of the team." Barrett also received the Combat Infantryman Badge, awarded for "exemplary conduct in action against the enemy."

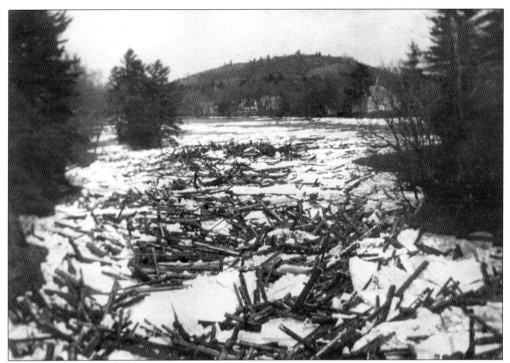

A logjam at Rockwell Falls is shown in 1919, the year of the great flood.

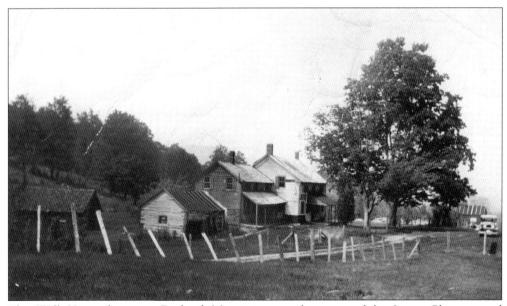

The Will Howe farm, on Bucktail Mountain, was later owned by James Clemons and Charles Anderson.

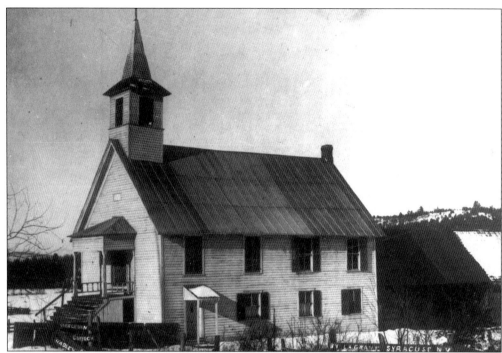

The Wesleyan Methodist Church was originally built on the Stony Creek Road in Hadley in the early 1900s. It was sold in the 1970s. A new church building is now located on Route 9N (Lake Avenue) in Lake Luzerne.

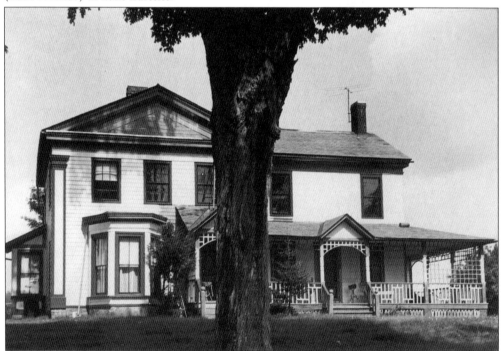

The Lottie Crannell home, formerly located on Wall Street in Lake Luzerne, is pictured here. It was razed by Niagra Mohawk in the late 1990s.

Read Park was built as a summer home by Maj. Harmon Pumpelly Read and his wife, Catherine DeCarron d'Allondons Read. The major was a world-renowned expert on symbolism and heraldry.

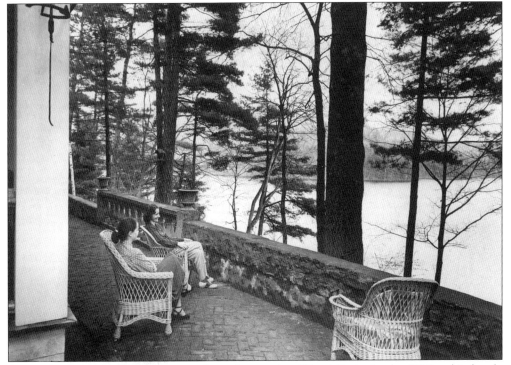

Pictured is a view of Lake Luzerne from the porch of Read Park. In the 1950s, this lovely residence was a rehabilitation facility called Health Haven.

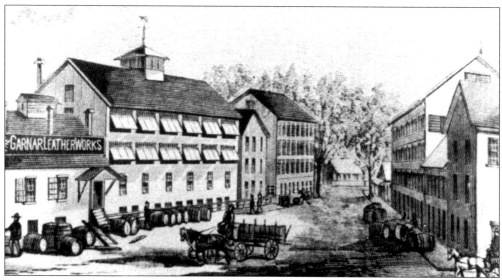

The Garnar Leather Works was located at the corner of Main and Mill Streets. Established in 1867 by the firm of Raymond and Ely, it was sold the following year to Thomas Garnar and Company. Thomas and his brother Edward Garner Sr. operated the tannery until it closed in 1909. The firm produced leather, which was mainly used in the bookbinding industry. The brick stack and some foundations are all that remain.

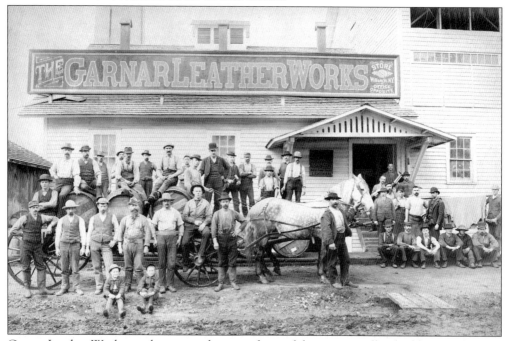

Garnar Leather Works employees are shown in front of the tannery office building on the west side of Main Street. Wagons brought casks of skins to the tannery for processing and then hauled the finished products to the railroad station in Hadley. The tanned hides were then shipped to New York City by rail and by boat. To the right, men are carrying hides on a pole. This was the way the hides were transported to the drying room. The children shown had probably brought lunch to their fathers, a common practice in the 1890s.

Two
LOCAL INDUSTRY

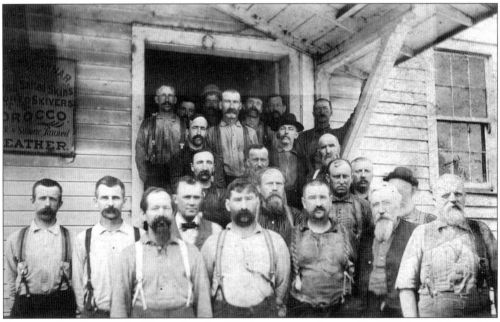

A group of workers at the Garnar Leather Works poses on August 25, 1898. From left to right are the following: (first row) Banty Stewart, Ira Westfall, Christopher De Long, Hamilton Shaw, John Beattie, William Snell, and Clark Baldwin; (second row) E.M. Garnar, Mack Willard, Harmon Taylor, Gene Traver, and James Hovey; (third row) William Stone, Billie Ross, and Robert Gell; (fourth row) George Gell and John Wright; (fifth row) Eben Stone, Charles Black, John Shay, James Holleran, Dan McCarthy, Jake Rist, and Frank Rice.

The office of the Garnar Leather Works is shown in 1894, with Edward Garnar sitting at his desk.

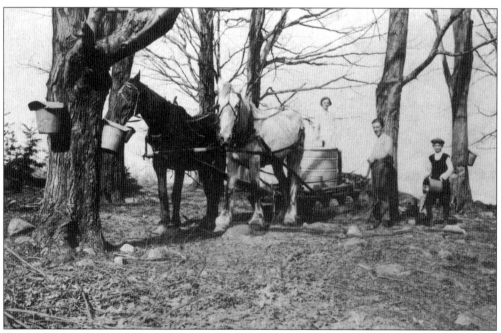

Freda Scofield, Homer Scofield, and their cousin Jeff Jeffers gather sap for maple syrup in their sugar bush.

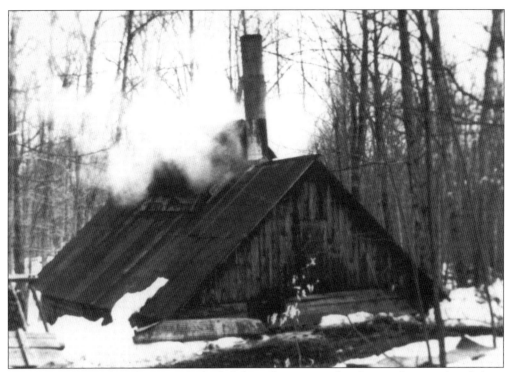

After the sap is gathered, it must be boiled down for syrup and jack wax. As is evident below, family members of all ages participated in the making of this delicacy.

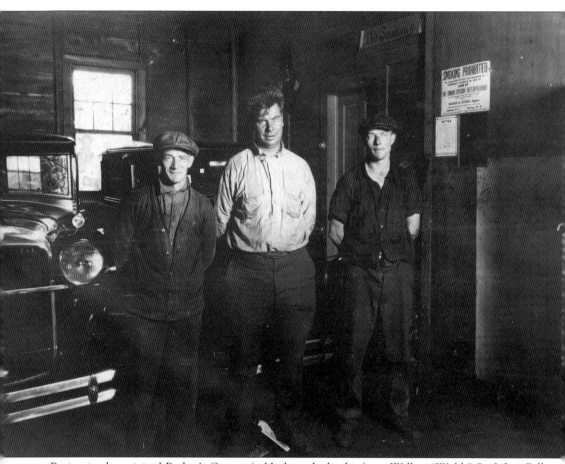

Posing in the original Parker's Garage (a Hudson dealership) are Wilbur "Webb" St. John, Bill Brown, and Frank Gardner.

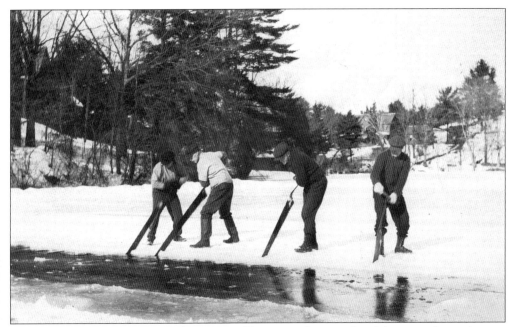

A group of workers saws ice on Lake Luzerne. The ice was harvested and then stored in icehouses.

Workers lift ice blocks from the lake.

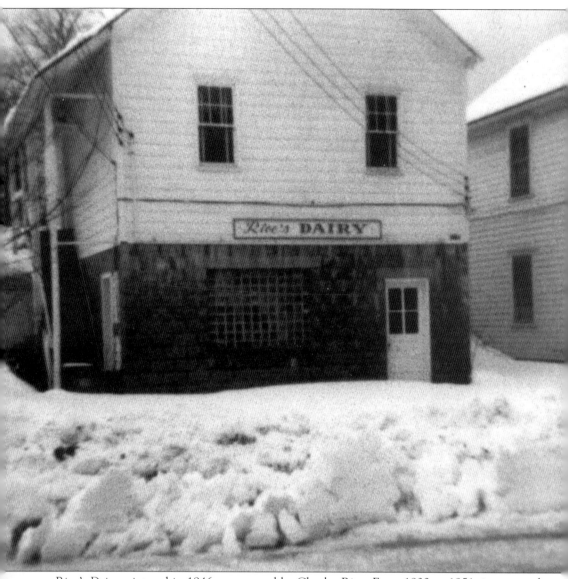

Rice's Dairy, pictured in 1946, was owned by Charles Rice. From 1932 to 1951, it was run by his daughter Catherine and her husband, Jay Denton. It was then run by John Stead until his death in 1963. The dairy was eventually closed and sold as a private residence.

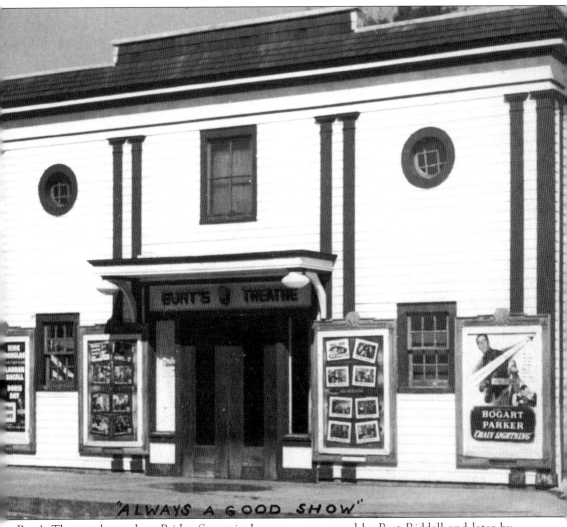

"ALWAYS A GOOD SHOW"

Burt's Theatre, located on Bridge Street in Luzerne, was owned by Burt Riddell and later by George Stanton. For many years, before television, this was the area's most popular source of entertainment.

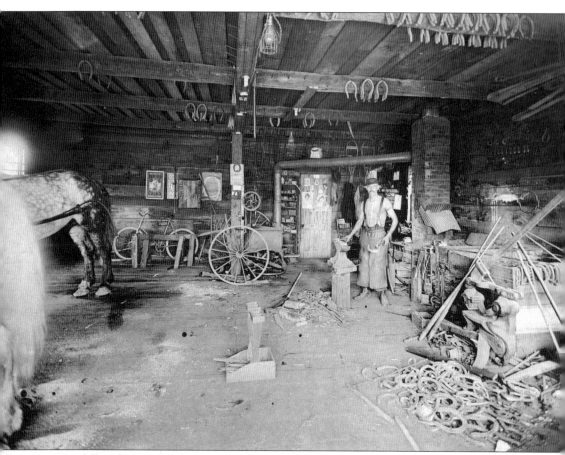

Wendell's Blacksmith Shop was located at the Four Corners in Hadley, at the present site of JR's Automotive.

The United Methodist Church, the oldest church in Luzerne, is located at its original site on Main Street. The house to the left was built by Benjamin Clapp Butler.

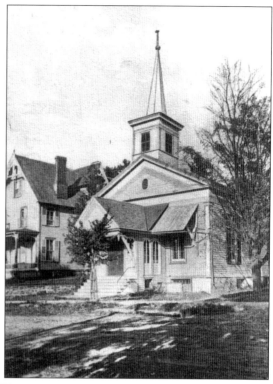

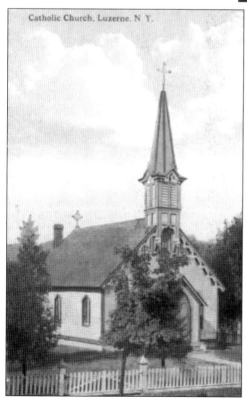

The Holy Infancy Roman Catholic Church, on Lake Avenue, was built in the mid-1800s. It was razed and rebuilt in the mid-1930s by workers on the Conklingville Dam project.

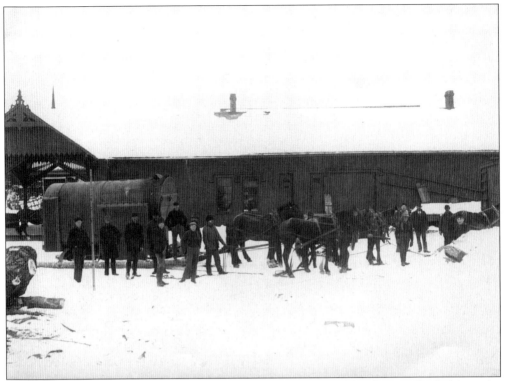

In this view of the Hadley depot, a new boiler for the paper mill has been unloaded from the train and is being readied to be drawn by horses to the mill.

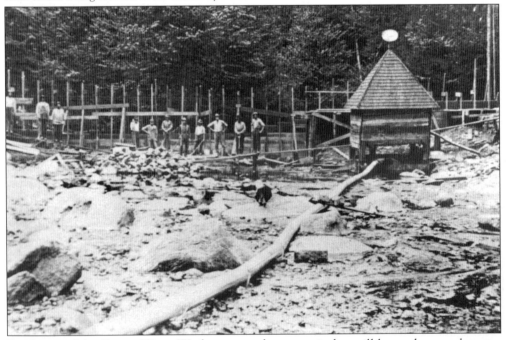

Employees of the Garnar Water Works prepare the reservoir that will be used to supply water to the town of Luzerne.

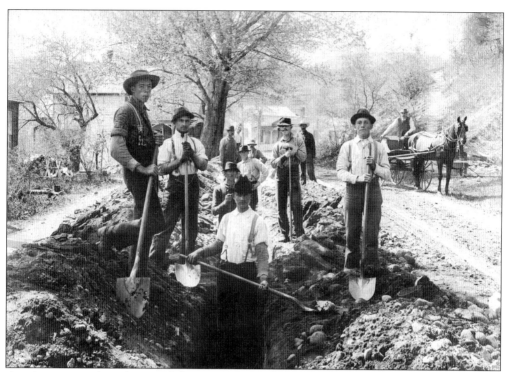

Another group of employees of the Garnar Water Works is digging the trench for the water lines along Wall Street.

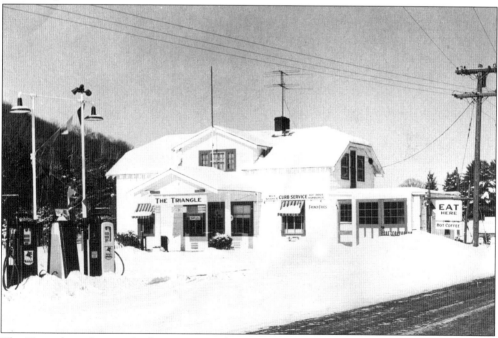

The Triangle, a drive-in built on a triangular piece of property on Route 9N in Hadley, was a favorite hangout for teenagers in the 1950s and 1960s. At one time, the waitresses worked on roller skates. It was owned and operated by Bob and Beverly Ryan.

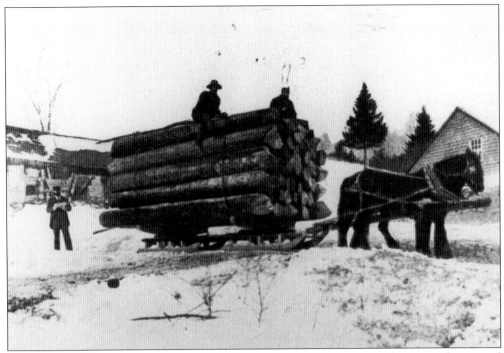

A team of draft horses is pulling a pair of bobsleds loaded with logs. The logging industry used this method for moving the logs in the winter.

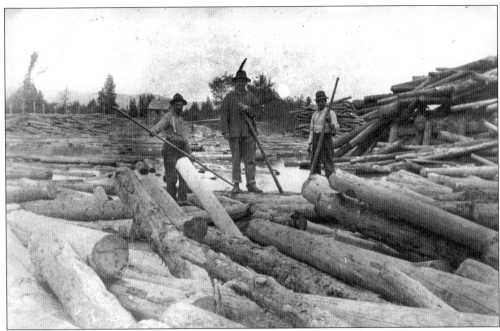

During a river drive, one of the most dangerous parts of the job was the sorting of the logs.

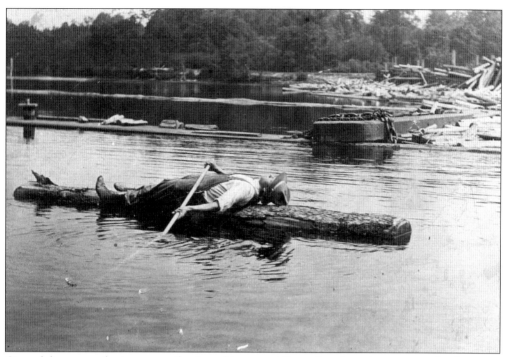
One of the most relaxing parts of a river drive was riding a log downriver on your back.

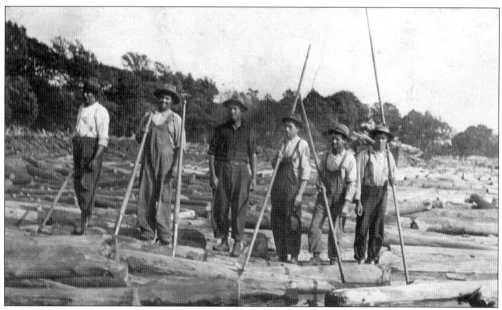
River drivers were very proud of their skills and loved to pose for pictures.

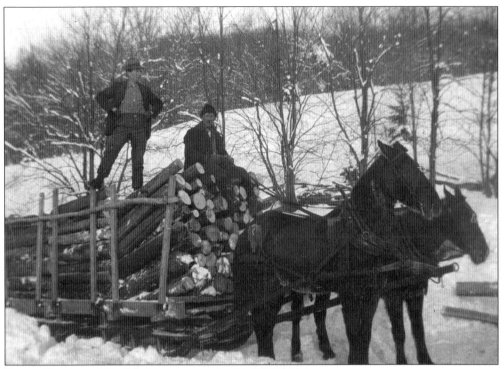

George Frasier and Fred Robison appear in this 1912 picture.

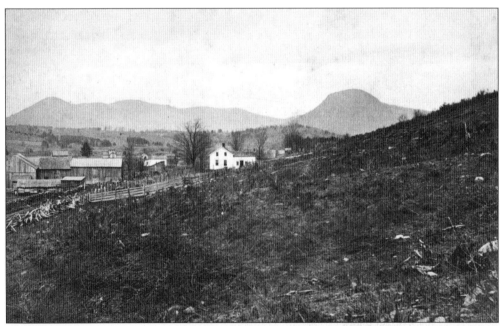

The Rockwell farm, once located north of Luzerne near the water tower site, is shown with Potash Mountain in the background. Note the absence of trees.

Knox Bishop's Garage, located just south of the traffic light on Route 9N, is now the site of Bernliner's Service Center. Bishop was well known for his mechanical ability and his sense of humor.

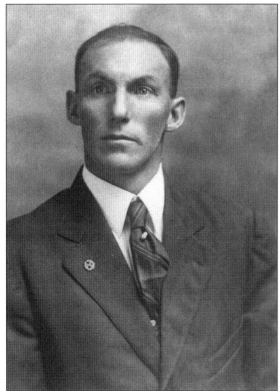

Ira Gray—a renowned hunter, fisherman, trapper, and author—was one of the best representatives of the pursuit of these sports. His friends knew him as Ike.

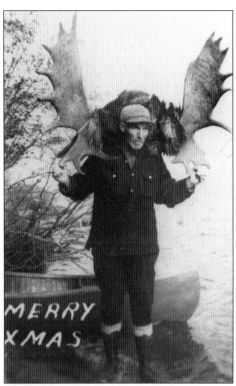

Ira Grey is shown on a successful hunting trip to Canada. He had a huge moose head hanging above his bed.

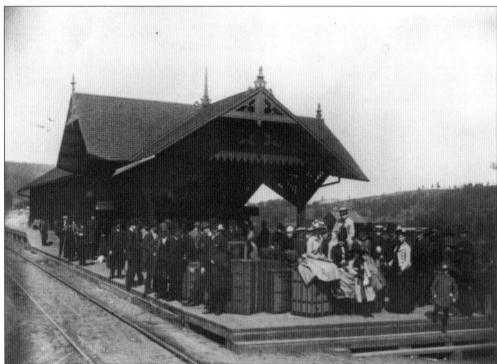

These passengers are waiting at the Hadley depot for the train that will take them home from their holiday in Luzerne.

On the Adirondack Branch

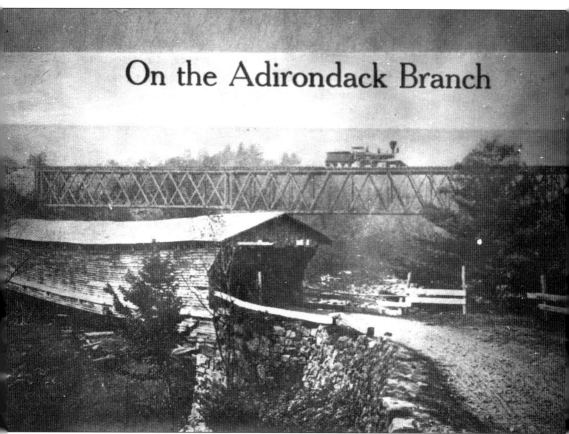

The "Major General Hancock" crosses the trestle above the Sacandaga River in Hadley, with the old covered bridge in the foreground. The photograph was taken by Seneca Ray Stoddard. Born in 1844 in Wilton, Stoddard became the most famous photographer of the Adirondack Mountains. His work includes some of the best photographs ever taken of Hadley and Luzerne. His studio was located in Glens Falls, and he traveled aboard the "Major General Hancock" of the Adirondack Railway when doing many of his photographs.

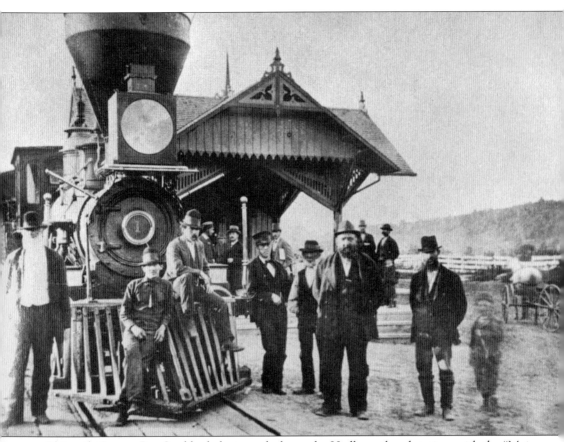

This early Seneca Ray Stoddard photograph shows the Hadley railroad station, with the "Major General Hancock" on the tracks. The two ghosts to the right are children who came into the group while the plate was still wet. The man next to the children may be Stoddard himself. The picture was probably taken by one of his associates.

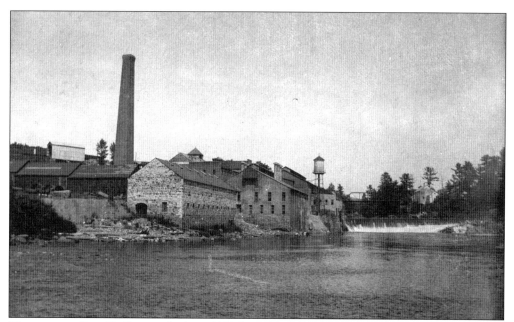

The paper mill in Hadley was built in 1878 by Marcus Gardiner and his father-in-law, Charles Rockwell, under the name Rockwell Falls Fiber Company. The mill became the property of the Union Bag and Paper Company and, later, of the Nu-Era Paper Company.

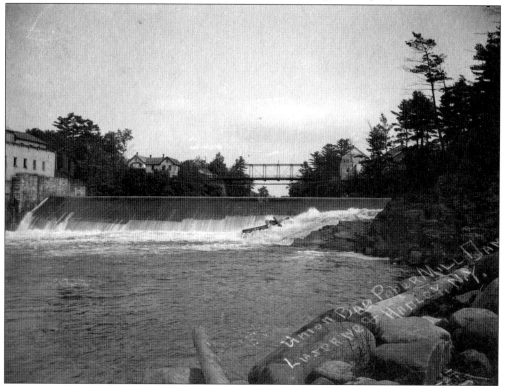

The dam for the Union Bag and Paper Company was located across the Hudson River below the natural falls. The dam washed out in the early 1930s and was never rebuilt.

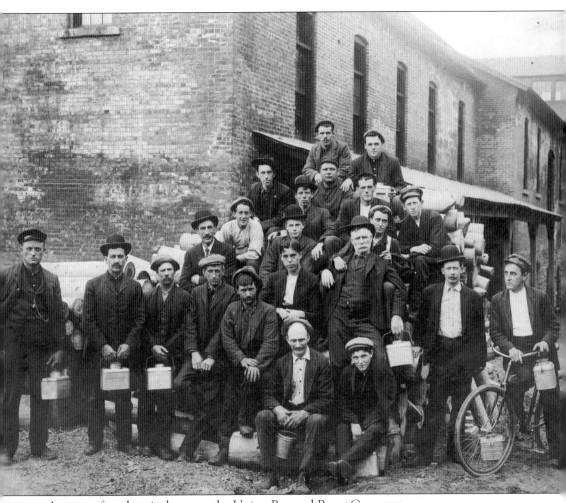

A group of workers is shown at the Union Bag and Paper Company.

Charles Williams's barbershop was located just below the drugstore and across from Lamoy's. Williams is shown giving a customer a shave.

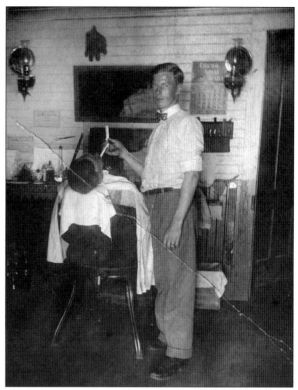

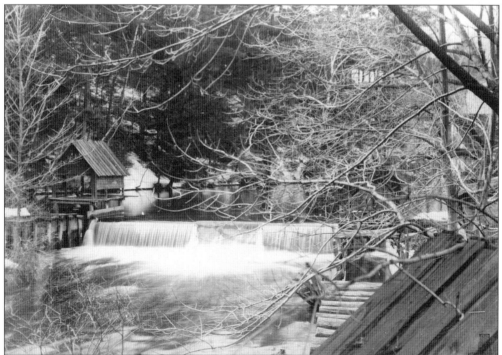

This view of the outlet of Lake Luzerne shows the stone dam and the gatehouse that controlled the flow of water to the pulp mill (and, later, to the gristmill 100 yards downstream).

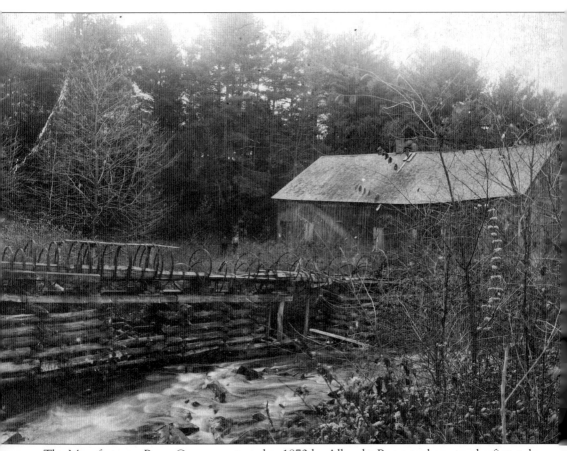

The Manufacturers Paper Company, started *c.* 1870 by Albrecht Pagenstecher, was the first pulp mill in this country. Part of the old flume and overshot waterwheel can be seen in this photograph.

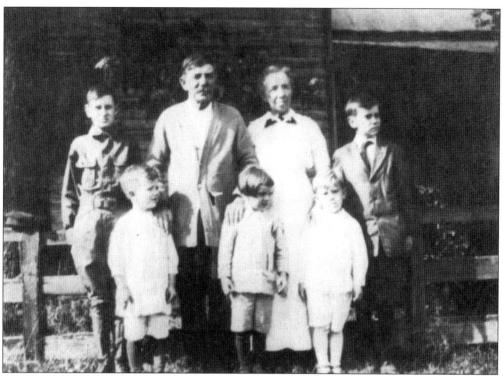

Friedrich Roider, shown with his wife and five children, was a German immigrant who came to Luzerne from Massachusetts to operate the new pulp mill.

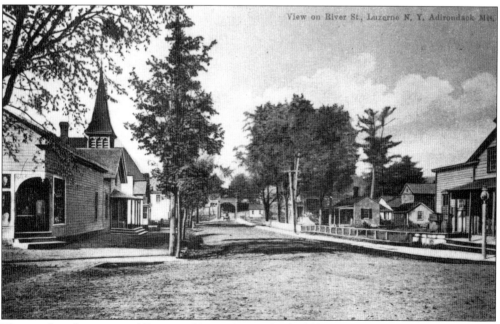

This is what the corner of River and Main Streets looked like in the mid-1800s. The original drugstore stands on the left corner, and Morton's Meat Market stands on the right corner.

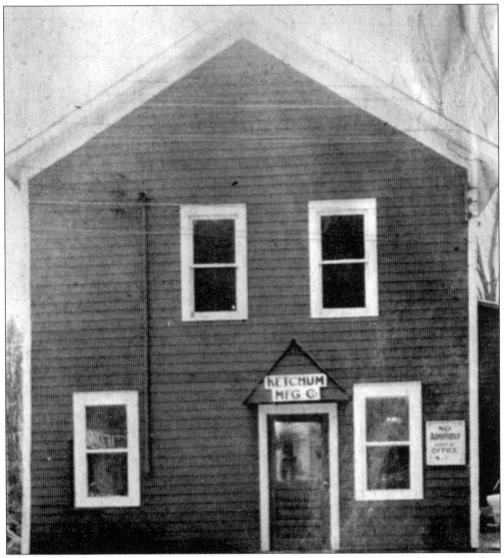

The Ketchum tag factory was started by Henry G. Ketchum in Cohoes and was moved to Luzerne in 1922 to a Wall Street building that had previously been a blacksmith shop and later a paint shop. Ketchum sold the business to Otis W. Howe and Rex B. Cotherman. In 1954, the business was sold to Norman F. Powers and Rex Cotherman Jr. Later, it was run by Norman Jay Powers and then by his son and daughter, Gary Powers and Lisa Podwirny. The company moved to its new home off East River Drive in 1962. Over the years, the company has manufactured all types of animal tags, pizza boxes, Thomas Taylor traps, and even branding irons. It is believed that this is the oldest surviving business in Lake Luzerne.

Three
VACATIONLAND

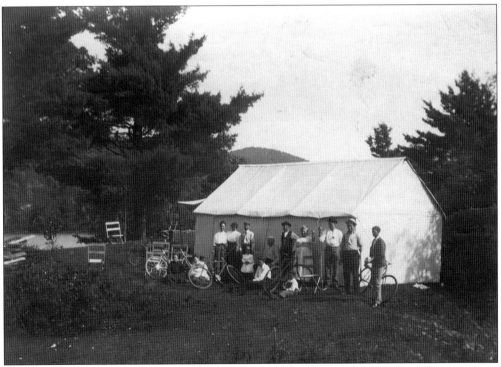

There were many forms of summer recreation in Luzerne. These bicyclists are gathered at their camp in Second Lake for a tour of the countryside.

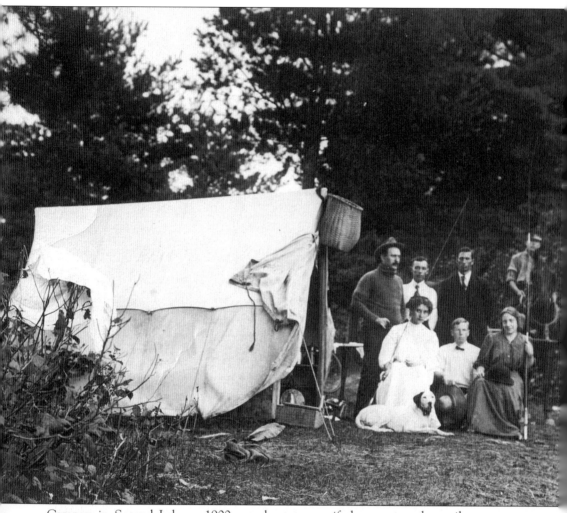

Campers in Second Lake *c.* 1900 are about to see if they can catch a wily trout or two for dinner.

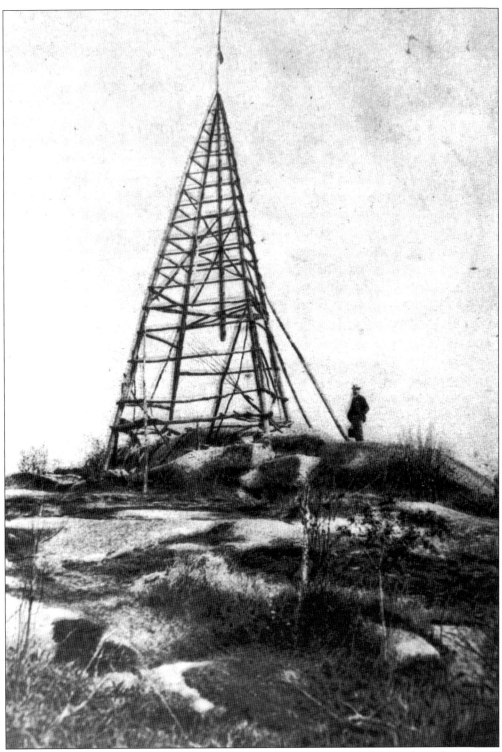

This tower, located atop Cobble Mountain in Luzerne, was probably used in the original mapping of the Adirondacks.

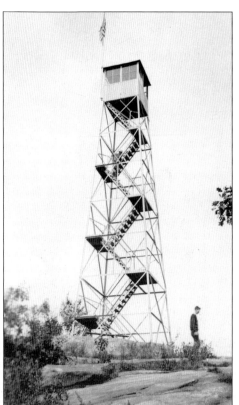

Pictured is the original fire tower atop Tower Mountain in Hadley. It was erected by the state as part of its efforts to avoid forest fires. The tower was manned 24 hours a day for many years.

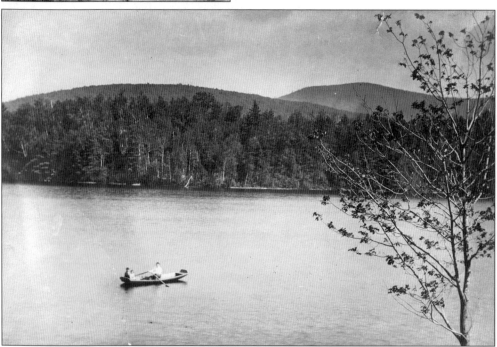

An unidentified mother and child enjoy a day of boating on Fourth Lake in Luzerne in the early 1900s.

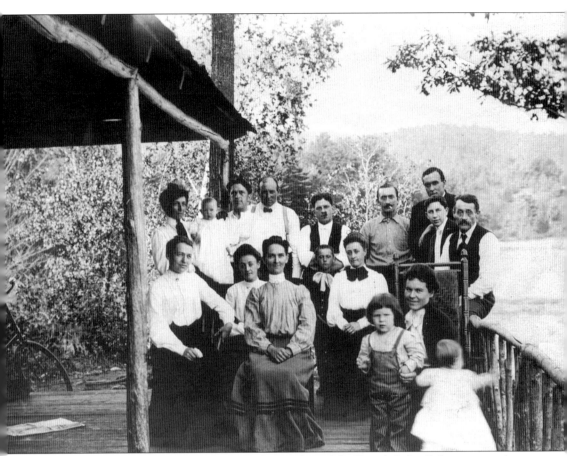

Members of a family, probably among the early founders of the Fourth Lake Colony, enjoy the lake view from the porch of their cottage c. 1910.

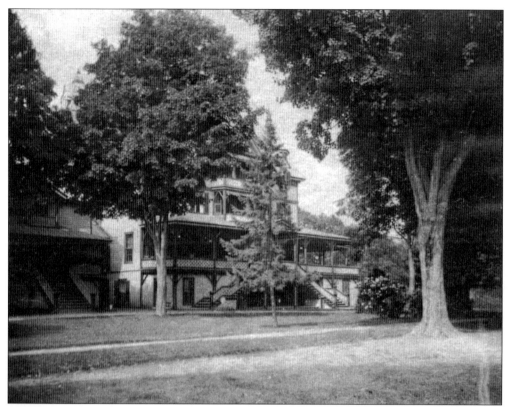

This view of the Wayside Inn shows that it was built in the high Victorian Gothic style. This building was destroyed by fire in 1938.

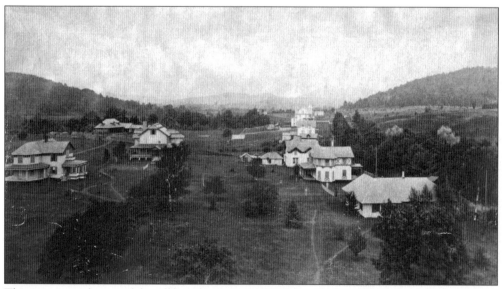

This is a view of some of the affiliated cottages of the Wayside Inn. They were also located on the 20-acre parcel on which the inn was sited.

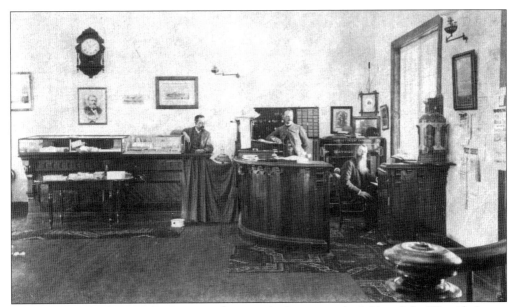

Desk clerks and other employees await the arrival of guests in the lobby of the Wayside Inn.

The Wayside Inn provided employment for local residents in jobs ranging from stable boy to telegraph operator. This view shows the interior of the inn. The dining room is to the right.

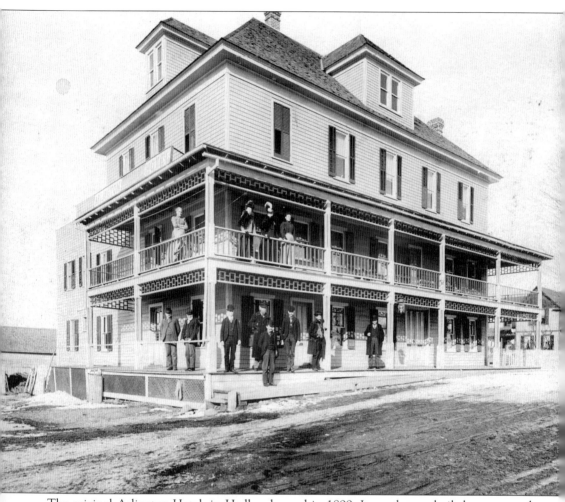

The original Arlington Hotel, in Hadley, burned in 1899. It was later rebuilt but not on the grand scale. In this view, Charles W. Traver is third from the left, standing on the front porch.

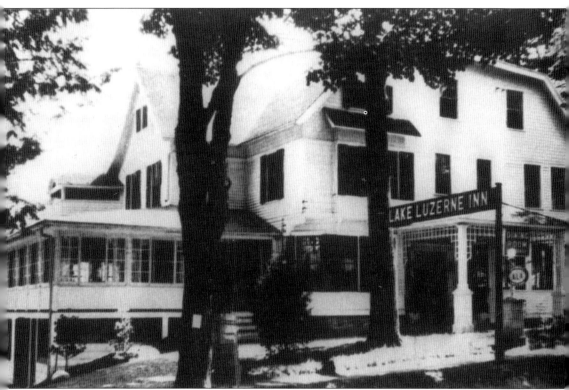

The Lake Luzerne Inn was built in the 1920s. It stood on the site of a cottage called the Minister's Cottage. It had some connection with the Price family, who owned Hazelwood. The Price daughter, who married the Duke of Marlboro, summered here. The inn was located on the site of the current Lake Luzerne Motel.

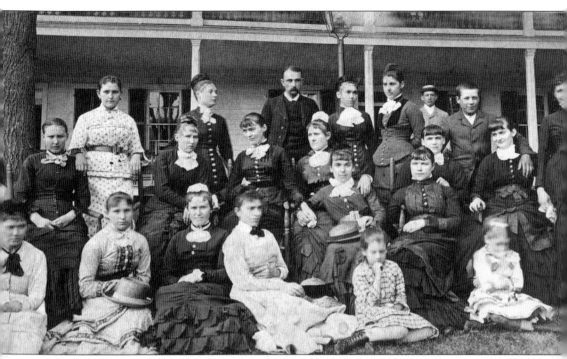

The housekeeper, chambermaids, waitresses, and other staff provided services for well over 100 guests at the Rockwell Hotel.

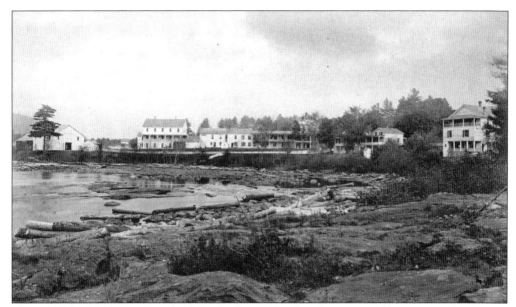

This 1880 Stoddard photograph of the Rockwell Hotel with annex and barns was taken from a vantage point near Rockwell Falls. The George Rockwell and Judson Perry homes and Stone's Opera House can be seen to the right.

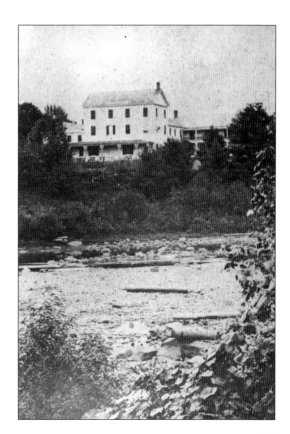

The Wilcox House, also known as the Riddell House and Riverview Hotel, overlooked the Hudson and Rockwell Falls on the Luzerne side of the gorge.

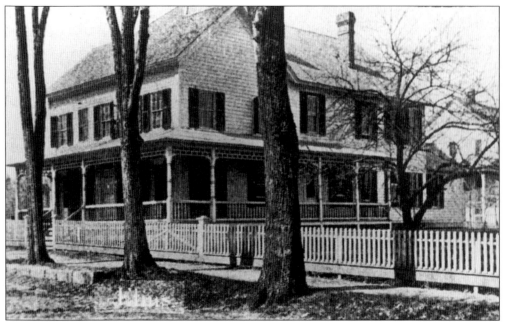

The Elms, a summer boardinghouse on Main Street, was the summer home of Commo. Cornelius Vanderbilt for several years. It stood on the site of the present town hall in Luzerne.

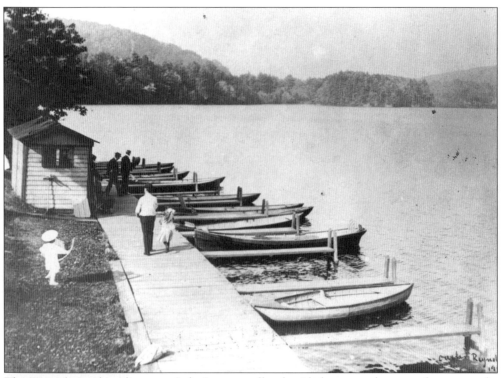

The Wayside Inn boat livery on Lake Luzerne offered guide boats, rowboats, and canoes to be used by the guests.

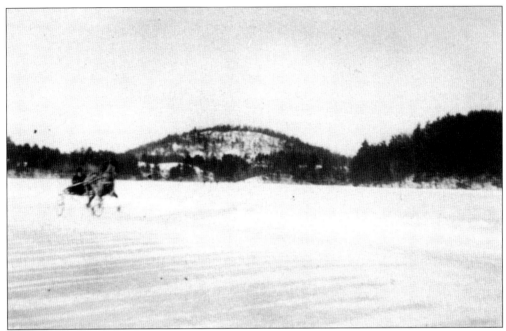

Coming down the ice at a rapid pace is an entrant in the horse races on ice. These took place on Lake Luzerne every weekend during February and March in the early 1900s.

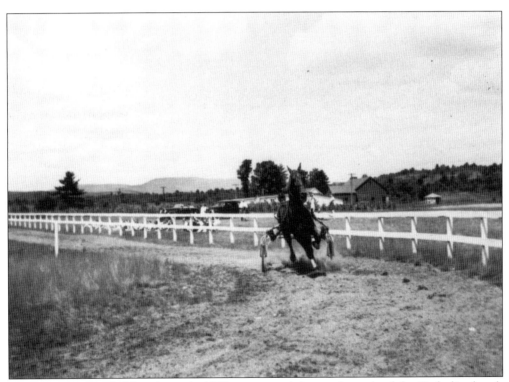

Harness races were held in the early 1900s on an oval dirt track north of the Catholic church on Lake Avenue.

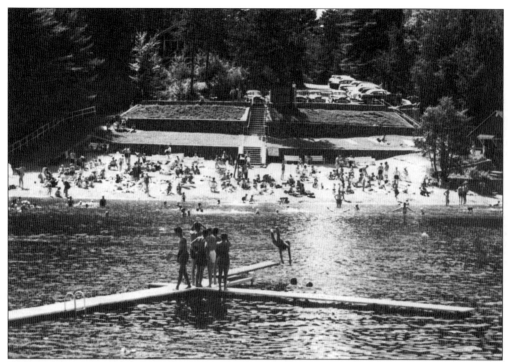

Pierpont Beach, on Lake Luzerne, is one of the three public beaches that still provide recreation to residents and guests.

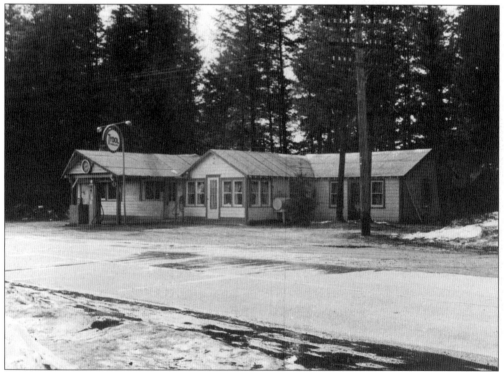

Pulver's Picnic Grove in Fourth Lake provided gasoline, snacks, and a dining area for residents.

The Chuckwagon diner, always in step with the times, provided a hitching rail for diners who arrived on horseback. This was an integral part of the dude ranch experience in the 1940s and 1950s.

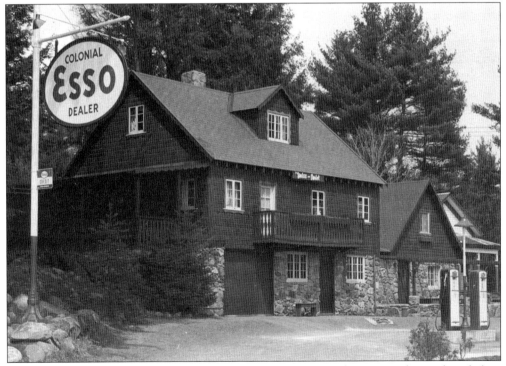

The Swiss Chalet, opposite the Hitching Post on Route 9N in Lake Vanare, featured a gift shop and gasoline pumps.

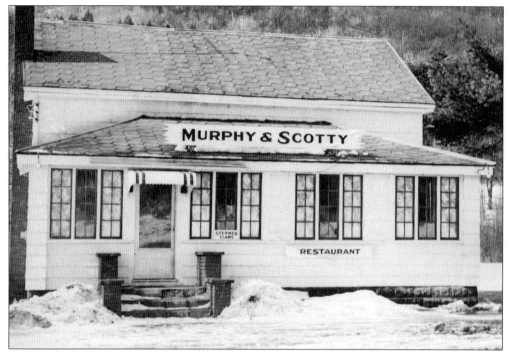

Murphy & Scotty was a popular local restaurant and bar on Route 9N in Hadley. It served the best pizza in town and, of course, the best draft beer.

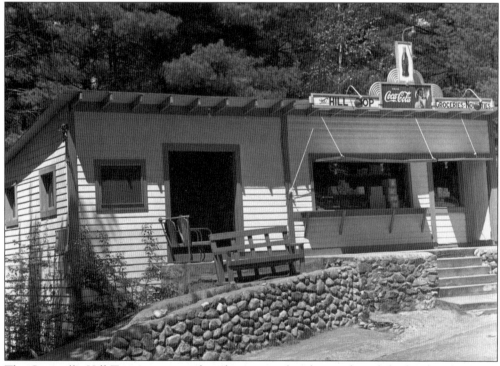

The Crannell's Hill Top store catered to the summer beach crowds and the local and summer residents in the area. The place was advertised as "on the hill but on the level."

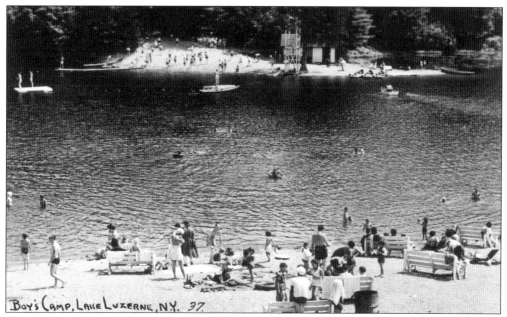

Campers from Camp Tekawitha are shown across Lake Luzerne from Pierpont Beach on the Luzerne Heights. The camp for Catholic boys was established in 1910. It was named in honor of Katiri Tekawitha, a Native American who was presented for sainthood in recent years. The camp is now the home of the Lake Luzerne Music Camp.

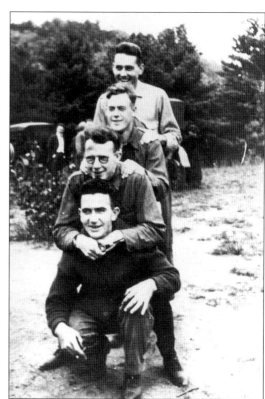

All four of these campers at Camp Tekawitha later became priests. They are, from front to back, Dennis Dillon, Thomas Lang, James Brennock, and Joseph Scully (who went on to become the bishop of Albany).

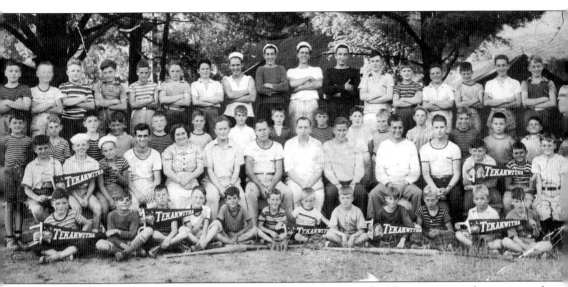

Tekawitha campers gather for an end-of-summer photograph. They appear to have enjoyed their sports and religious activities.

Frances G. Kinnear (second from left) plays with her friends and sister on the front steps of the Kinnear family home in Luzerne. A graduate of Hadley-Luzerne High School and Wellesley College, she became a high school physical education teacher, a World War II ambulance driver, and founder of Pine Log Camp for girls on Second Lake.

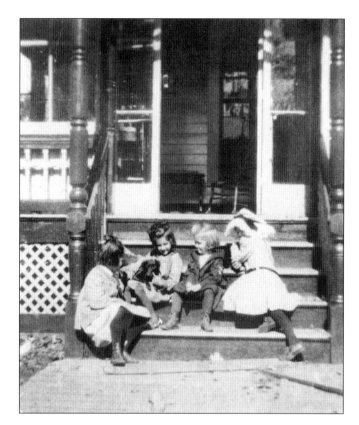

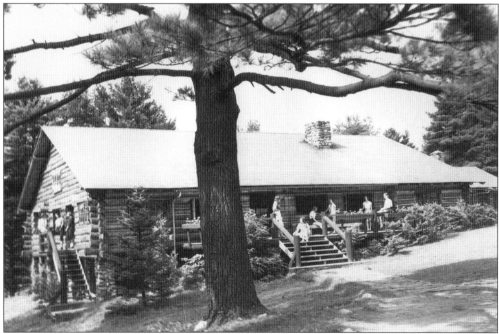

The main lodge at Pine Log Camp held space for a library, craft center, film-developing room, and dining room. Several campers are shown on the front porch of the main lodge.

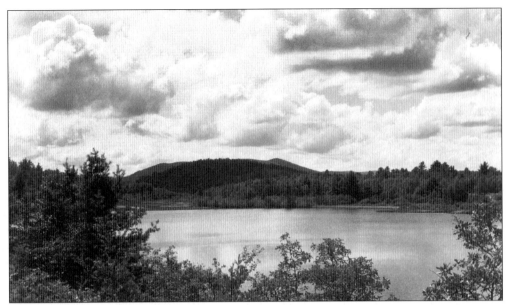

This is a view of Second Lake from Pine Log Camp. The lake was formed when glaciers deepened and widened a stream.

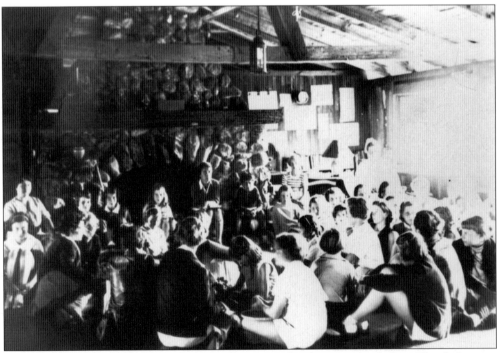

Pine Log campers gather around the native-stone fireplace in the lodge. The lodge was destroyed by fire in 1989.

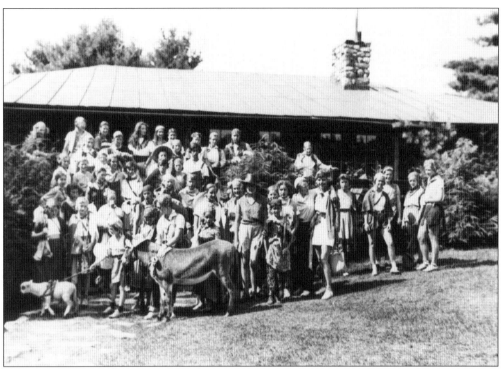

Girls from ages 10 to 18 were welcome at Pine Log Camp. Most of them stayed for the entire summer season.

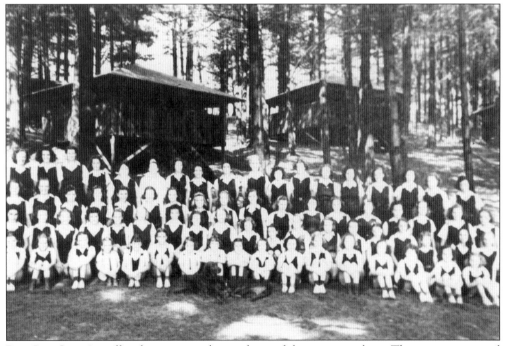

Pine Log Camp's staff and campers gather in front of the camper cabins. The property, owned by Pine Log Camp, completely surrounded Second Lake.

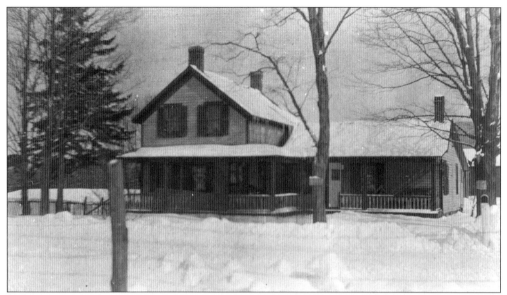

Pine Log Camp also had its own farm, which provided fresh vegetables, chickens, and eggs for the girls. The farmhouse and a few barns still exist on Route 9N north of the village.

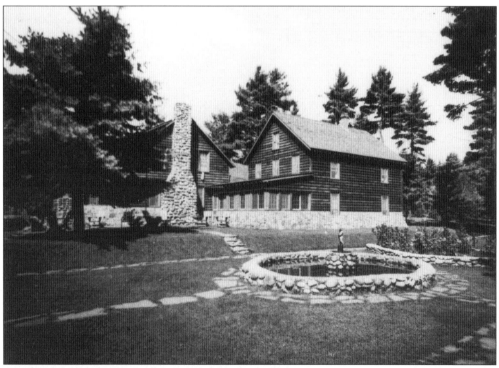

The Northwoods Dude Ranch was established in 1928. Founded by Earl Woodward, it was the first dude ranch in Lake Luzerne.

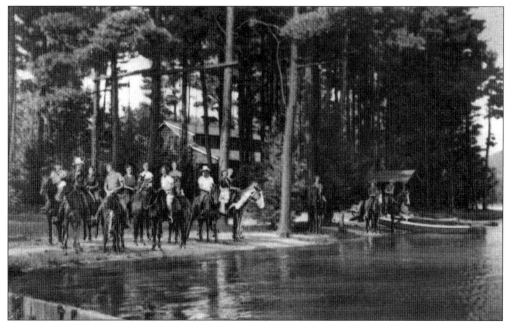

Northwood's riders pause for a rest. For $4 per day, guests could enjoy riding, swimming, tennis, fishing, and fine food.

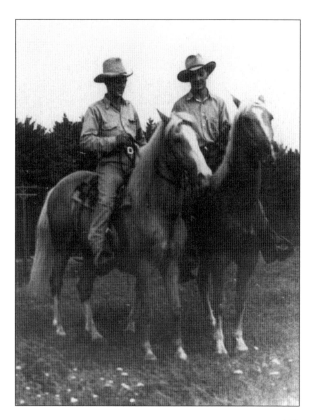

Two Northwoods cowboys stand ready to lead riders of all abilities on a trail ride.

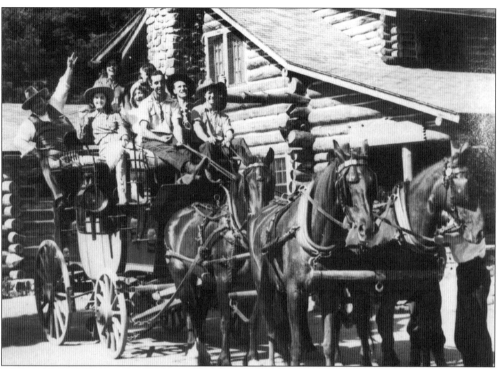

The Hidden Valley Dude Ranch stagecoach is taking guests on a Sunday ride.

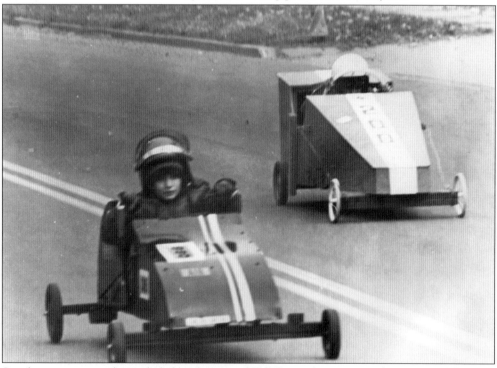

Soapbox racing was also included in the annual Fall Festival activities. These young folks were stiff competitors.

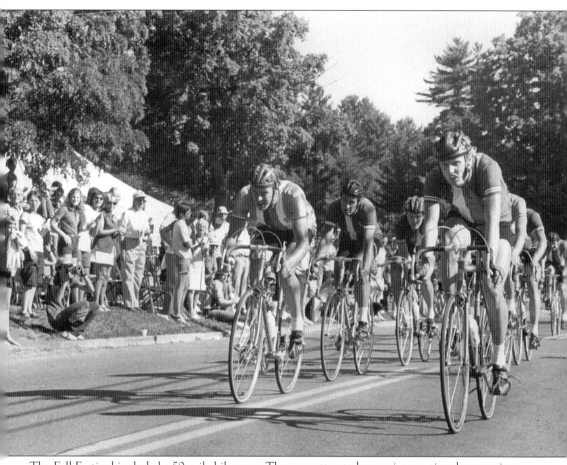

The Fall Festival included a 50-mile bike race. The race attracted many international competitors.

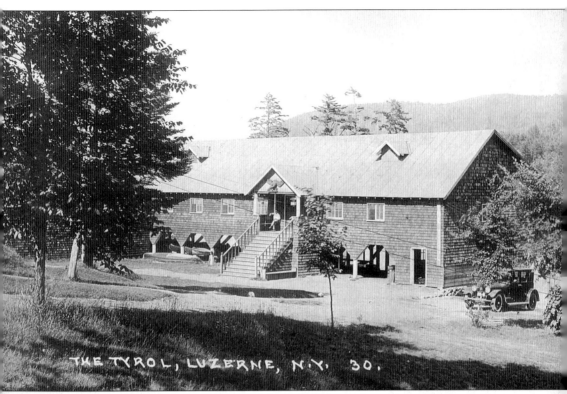

The Tyrol in Luzerne was a boathouse and dance hall. It was located on the site of what is now Wayside Beach. Built in the 1920s by Wilson Smead, it was used by the youth of the community as a place to warm up after ice-skating.

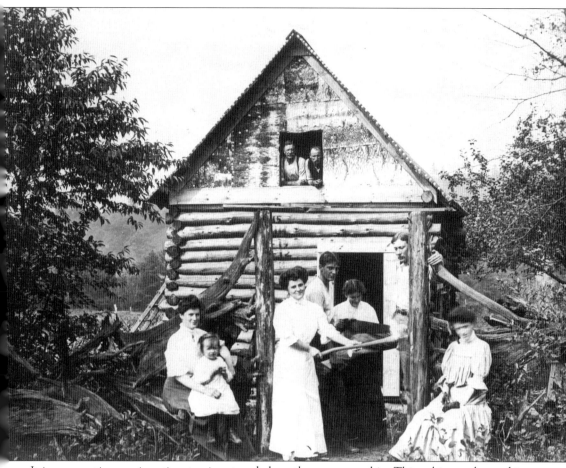

It is summertime again—time to air out and clean the summer cabin. This cabin was located in Hadley during the early 1900s.

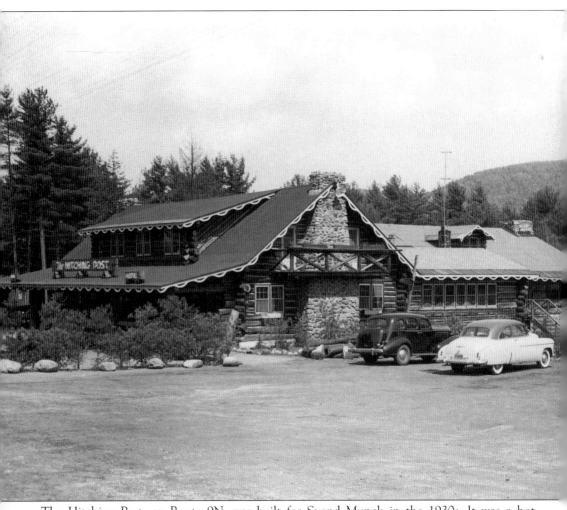

The Hitching Post, on Route 9N, was built for Svend Munck in the 1930s. It was a hot nightspot for many years and was one of the most unique log structures in the country at the time.

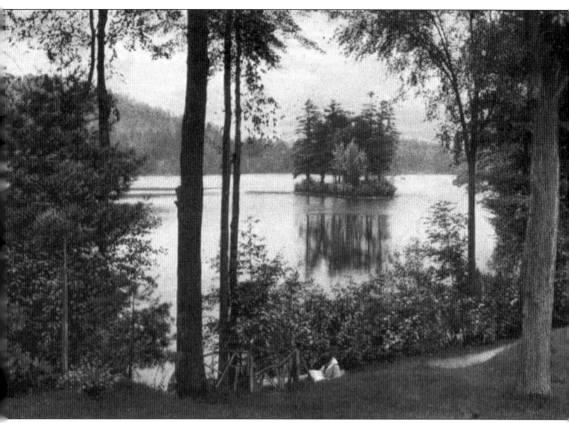

Ivy Island, a distinguished landmark for Lake Luzerne, is the jewel of the lake.

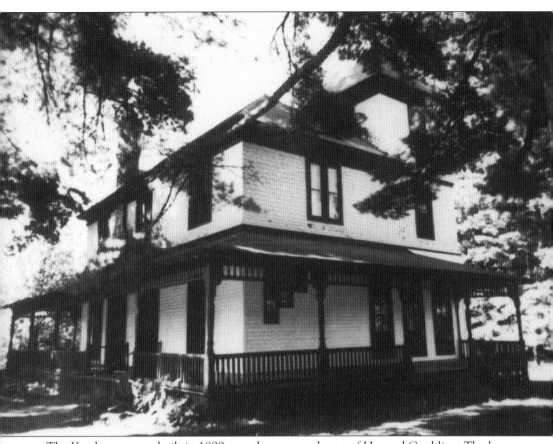

The Ketchum estate, built in 1899, was the summer home of Howard Conkling. The house was sold in 1922 to Henry C. Ketchum, owner of the tag factory. In 1985, the new owners, Eugene and Linda Merlino, opened it as a luxurious bed-and-breakfast. It is called the Lamplight Inn.

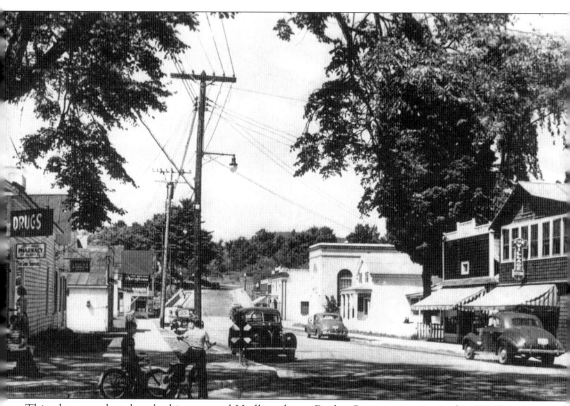

This photograph, taken looking toward Hadley, shows Bridge Street as it appeared in 1935.

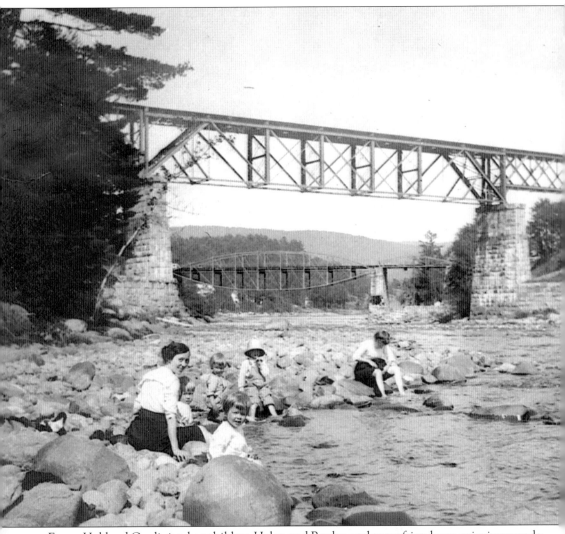

Fanny Hubbard Gardinier, her children Helen and Rocky, and some friends are enjoying a wade in the waters of the Sacandaga River. They are at the confluence of the Sacandaga and Hudson Rivers. The train trestle and the famous Bow Bridge are behind them.

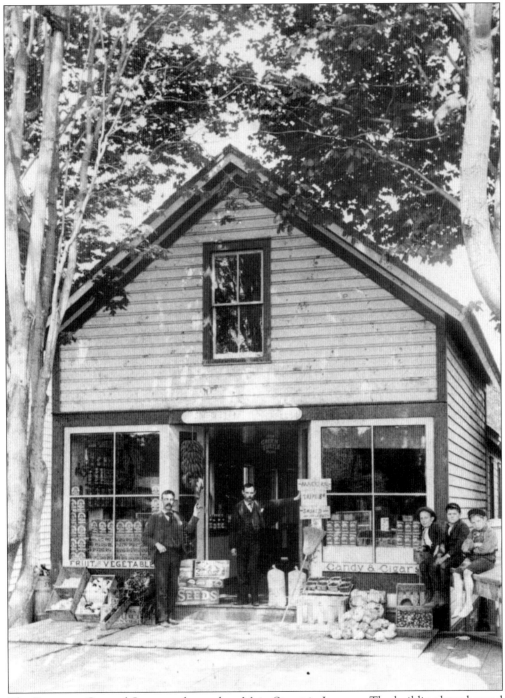

The Burneson General Store was located on Main Street in Luzerne. The building later housed the post office until 1980.

In 1936, just as milk was delivered to your door, so was meat. Bear Holland and his wife proudly display their meat wagon.

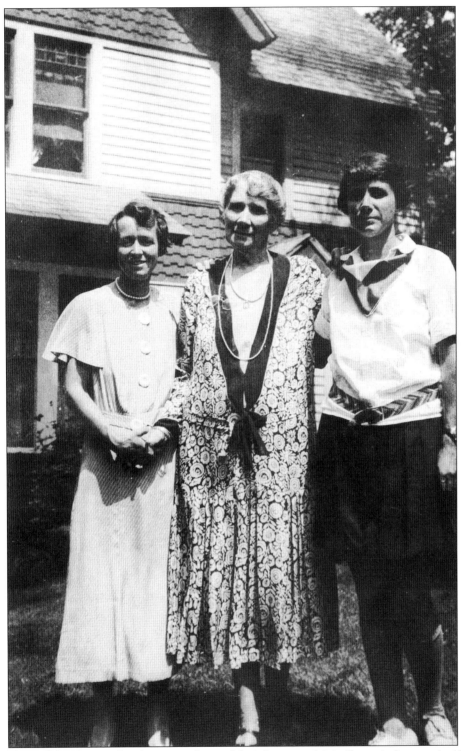

Members of the Kinnear family pose in front of their home on Main Street in Luzerne in 1924. From left to right are Helen Kinnear LaPrelle, Annie Garnar Kinnear, and Frances G. Kinnear.

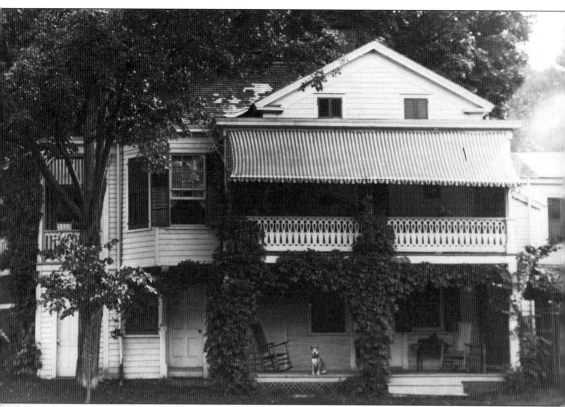

One of the Rockwell Hotel cottages is shown from the bank of the Hudson River. Now known as the Harmon House, it is owned by the Kinnear Museum of Local History.

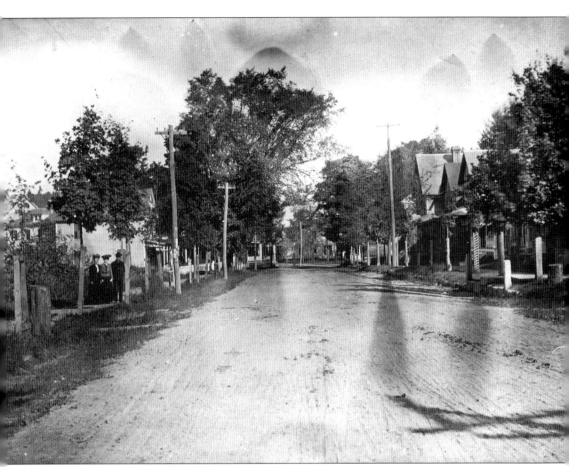

Main Street in Luzerne is shown in an early-1900s view looking north.

This *c.* 1908 postcard view of Church Street, in the town of Luzerne, looks west toward Lake Avenue.

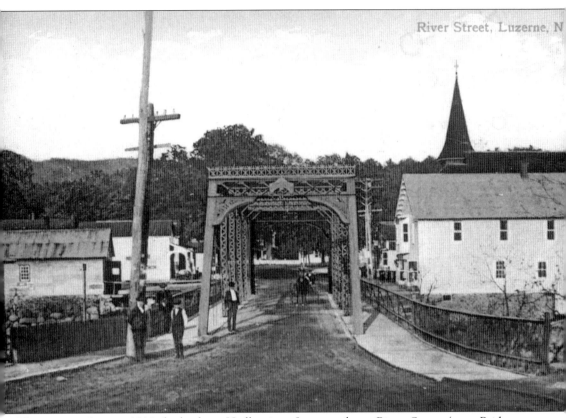

This view, taken c. 1910, looks from Hadley into Luzerne down River Street (now Bridge Street). This is the iron bridge that preceded the current bridge.

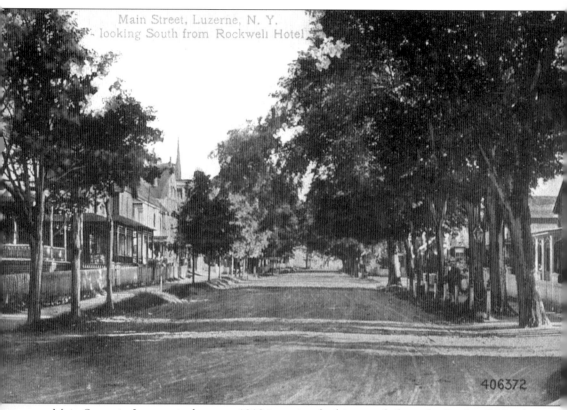
Main Street, Luzerne, N. Y.
looking South from Rockwell Hotel

406372

Main Street in Luzerne is shown *c*. 1910 in a view looking south from the Rockwell Hotel.

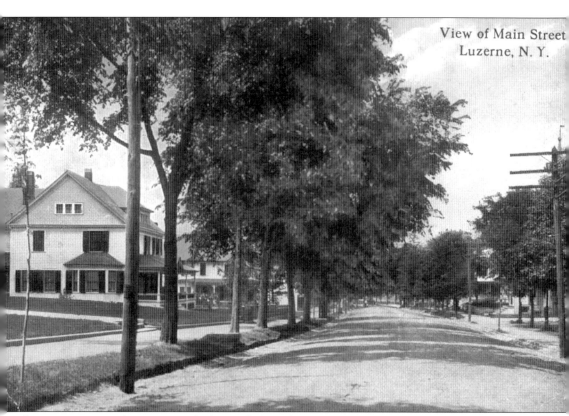

This *c.* 1910 view of Main Street looks north from the Garnar House.

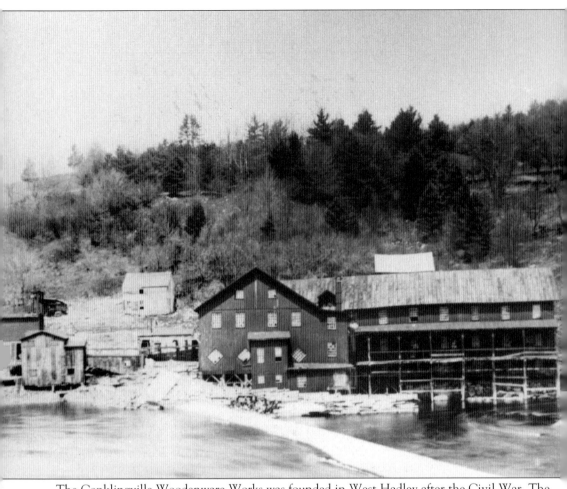

The Conklingville Woodenware Works was founded in West Hadley after the Civil War. The plant manufactured buckets, clothespins, washboards, and wooden barrels. Some of the concrete barrel forms can still be seen in the spring when the water is low in the Great Sacandaga Lake.

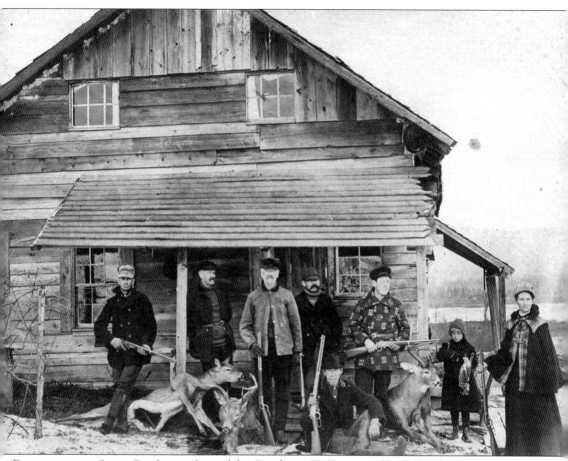

From a camp in Stony Creek, members of the Goodness, Williams, and Mills families are about to embark on a hunting expedition *c.* 1913. They are, from left to right, Bert Williams of Luzerne, unidentified, John Shay of Luzerne, Wilbur Mills, unidentified, Irving Goodness, Lee Goodness, and Grace Goodness.

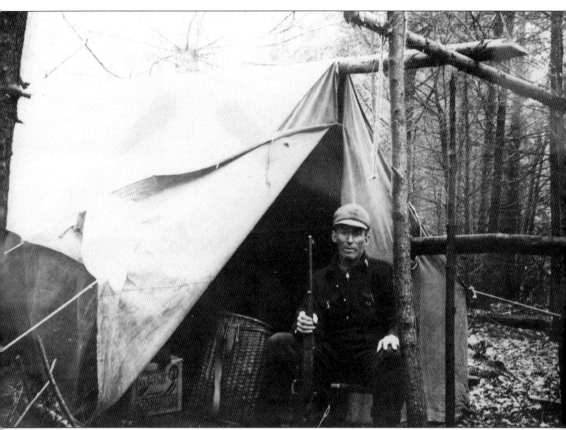

Ira Gray, a woodsman and licensed guide, camps in the wilderness, waiting for the big rack buck. He was skilled in woods lore, hunting, trapping, and fishing.

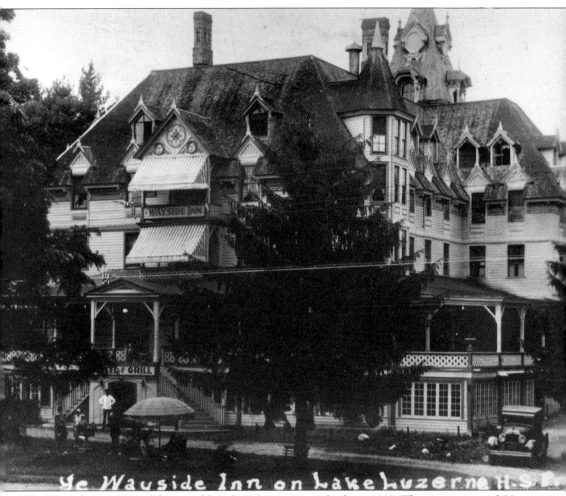

Ye Wayside Inn on Lake Luzerne H. S.

The Wayside Inn, one of the grand hotels in Luzerne, was built in 1869. The site contained 20 acres, the inn, and several affiliated cottages used by vacationers. The main building could house about 200 guests. Some of the guests who signed the register included Ulysses S. Grant, Diamond Jim Brady, and Lillian Russell.

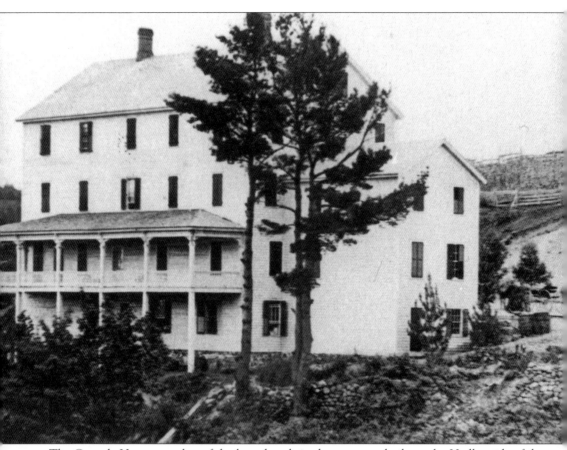

The Cascade House, another of the large hotels in the area, was built on the Hadley side of the bridge. Details on this hotel are scarce, but it is believed to have been built before the Civil War.

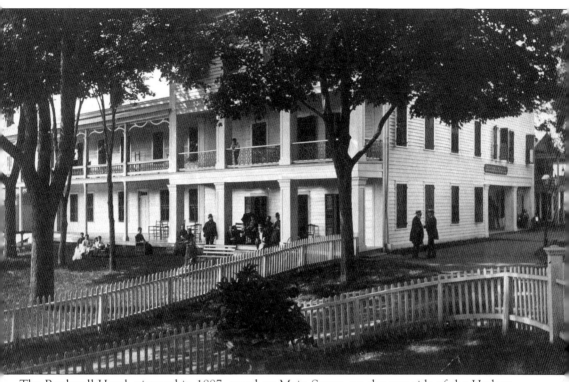

The Rockwell Hotel, pictured in 1887, stood on Main Street, on the east side of the Hudson. The site is now occupied by tennis and basketball courts.

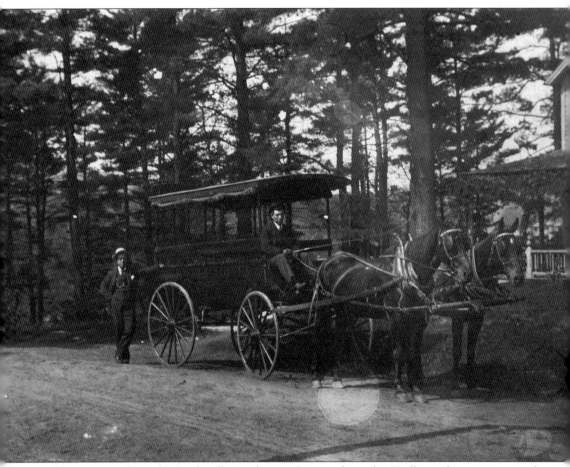

This carriage from the Rockwell Hotel carried guests from the Hadley railway station to the hotel. It was entered from the back, and the seats ran along each side lengthwise.